W9-BXX-118

THE LIBRARY OF CONGRESS
AMERICA'S MEMORY

Carol M. Highsmith
and Ted Landphair

FULCRUM PUBLISHING
GOLDEN, COLORADO

ACKNOWLEDGMENTS

The authors would like to thank the following people for their contributions to *The Library of Congress: America's Memory*. At the Library of Congress: Librarian of Congress James H. Billington, Margaret E. Wagner, Sara Day, John Y. Cole, James W. Gilreath, Ronald E. Grim, Clark W. Evans, Peter VanWingen, Rosemary Plakas, George B. Chiassion, James Hardin, Sharon Horowitz, Victoria C. Hill, Michael W. Grunberger, Alice L. Birney, Constance Carter, Frank Evina and Craig D'Ooge. At Fulcrum Publishing: Bob Baron, David Nuss, Jay Staten, Ed Meidenbauer, Steve Haberler, Sandy Trupp and Mark Carroll. Carol M. Highsmith would like to thank her associate, David Hofeling, for assisting with the lighting, camera setup and all the photographic elements of this book.

Copyright © 1994 Carol M. Highsmith and Ted Landphair

All photographs are by Carol M. Highsmith except where otherwise indicated. Copyright © 1994 Carol M. Highsmith.

Cover: The Great Hall of the Jefferson Building, fully restored and lovingly cleaned for the building's centennial, incorporates some exquisite art into its decor: Frank W. Benson's depictions of *Spring, Summer* and *Fall* top the balcony doors; Philip Martiny's cherubic figures next to the Grand Staircase represent Africa and America. (Photograph by Carol M. Highsmith)

Title Page: The detailed bronze work of the lamps and classical ornamentation of the windows and columns make the Jefferson Building as much an attraction as its neighbor, the Capitol. Even without the priceless treasures within the Library, the building itself would remain one of the nation's delights. (Photograph by Carol M. Highsmith)

Cover design by Ann E. Green, Green Design

Printed by Sung In Communications Co. Ltd., Seoul, Korea
0 9 8 7 6 5 4 3 2 1

No part of this publication may be reproduced, stored in a retrieval system or transmitted in any form or by any means, electronic, mechanical, photocopying, recording or otherwise, without the prior written permission of the publisher.

All Rights Reserved

Library of Congress Cataloging-in-Publication Data
Highsmith, Carol M., 1946–
 The Library of Congress : America's memory / Carol M. Highsmith and Ted Landphair.
 p. cm.
 Includes index.
 ISBN 1-55591-188-9
 1. Library of Congress—History. 2. National libraries—Washington (D.C.)—History. I. Landphair, Ted, 1942– . II. Title.
Z733.U6H54 1994
027.573—dc20 94–19914
 CIP

Fulcrum Publishing, 350 Indiana Street, Suite 350
Golden, Colorado 80401-5093

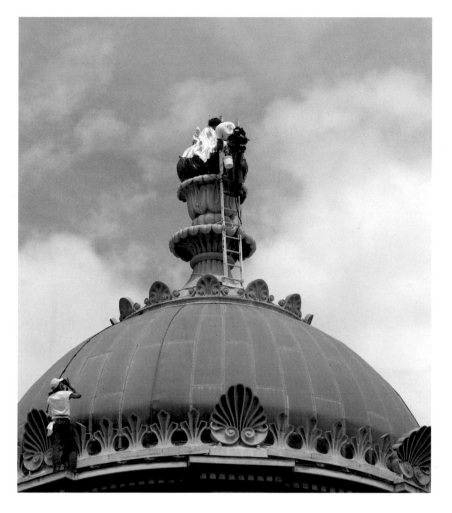

Left: Nearly two hundred feet in the air, workers gild the Torch of Learning on top of the dome of the Jefferson Building. The original gilding, which covered the entire dome, wore off years ago. (Photograph by Carol M. Highsmith)

TABLE OF CONTENTS

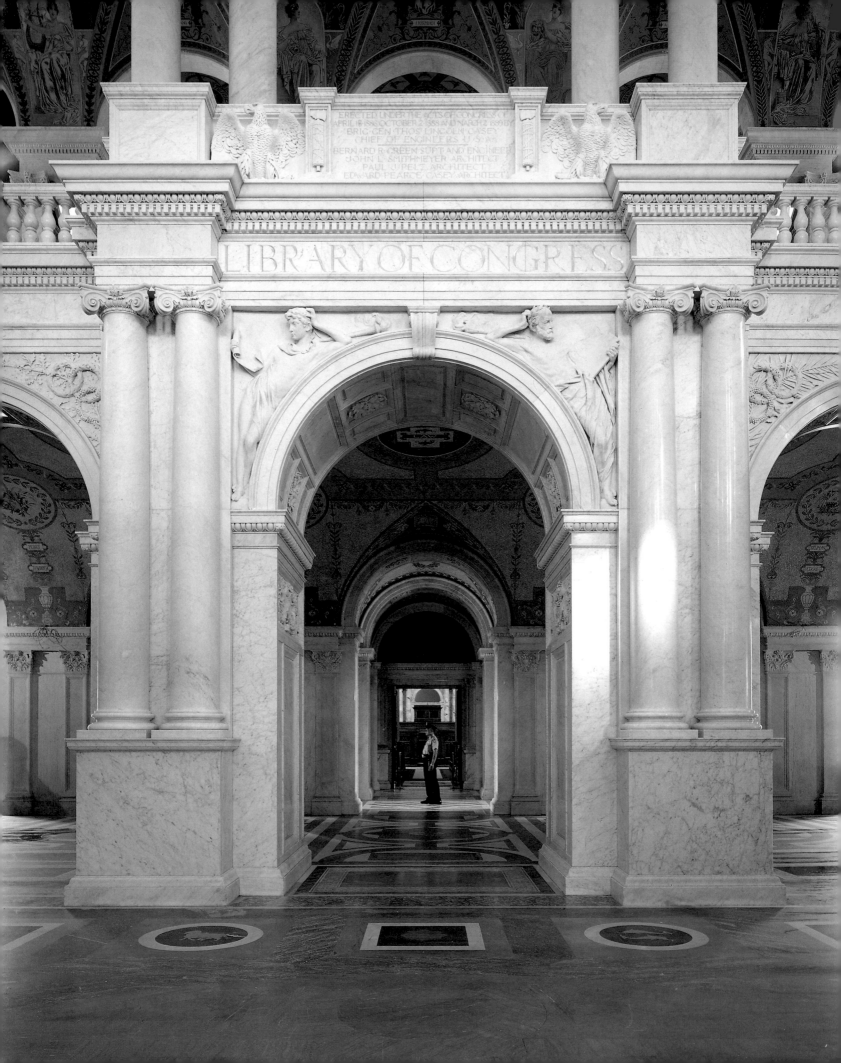

PREFACE

America's Memory

The Library of Congress, America's oldest national cultural institution, will be two hundred years old in the year 2000. On April 13, 1993, the 250th anniversary of the birth of Thomas Jefferson (whose personal library formed the core of Congress's own collection), bicentennial celebrations were launched with a ceremony. That day, I received on behalf of the Library its symbolic 100 millionth acquisition, a collection of 745 watercolor paintings and pencil drawings by American artist John Rubens Smith.

It may surprise many people that the Library is actively collecting original works of art. However, Jefferson himself insisted there was "no subject to which a Member of Congress may not have occasion to refer." The Library's staff has held fast to this vision of multicultural, multimedia collections ever since. Extraordinary treasures and collections—books and periodicals in more than 460 languages, maps, manuscripts, music, prints and photographs, film and even three-dimensional objects—have poured into the Library over the years through donation, copyright registration, purchase and exchange.

This book, filled with stunning photographs of many of these treasures, provides an entertaining and anecdotal

Left: The Commemorative Arch of the Great Hall is topped by Olin Levi Warner's spandrel figures. The library guard stands in the corridor leading to the Main Reading Room. (Photograph by Carol M. Highsmith)

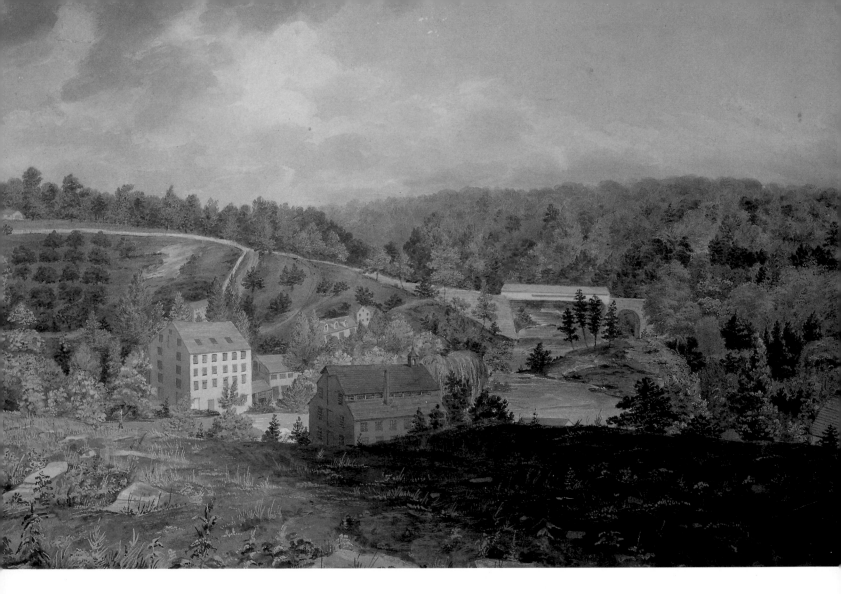

Above: This watercolor painting, Mill on the Brandywine, Delaware, *by John Rubens Smith in 1830, was part of the John Rubens Smith collection presented to Librarian of Congress James H. Billington in 1993 as the Library's symbolic 100 millionth acquisition. The collection was a gift from the Madison Council and Mrs. Joseph Carson. (Courtesy of the Library of Congress)*

tour through the Library's history, specialized collections and multifaceted functions. At the center of this tour is the Library's most spectacular treasure, the Jefferson Building, whose centennial will be celebrated in 1997 when it reopens after massive refurbishment. In the spirit of infectious optimism typical of the late nineteenth century's Gilded Age, American and European craftsmen were commissioned to embellish this vast American Renaissance building with marble, mosaic, paintings and sculpture to richly symbolize the country's grand entrance onto the world intellectual stage. The Library's first separate building was completed under budget and on deadline, an accomplishment that is roundly appreciated in these budget-conscious times.

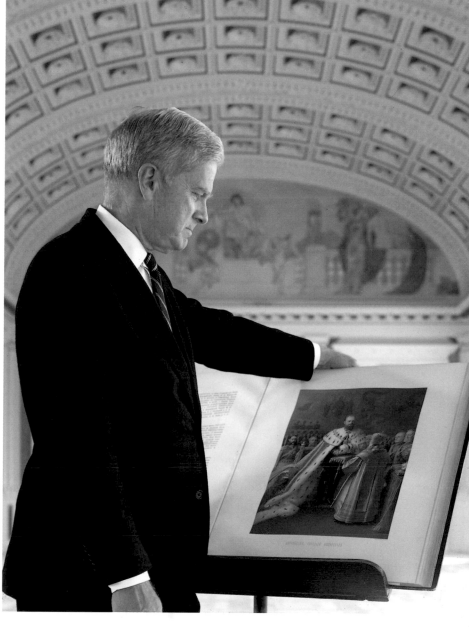

Right: Librarian of Congress James H. Billington stands with the coronation book for Czar Alexander III in the Southwest Gallery of the Jefferson Building. (Photograph by Carol M. Highsmith)

The necessity of operating this complex institution within increasingly limited budgets today, along with new concern for the security of the collections, has not dampened my determination to "get the champagne out of the bottle," to give the American people, and the rest of the world, broad access to the riches of the world's largest repository of knowledge. One way of achieving this is by harnessing computer technology to create a "library without walls." It should not be long before the numbers of those who have online access to "America's Memory"—the Library's comprehensive database and special collections—will far outstrip those who visit the Library in person.

This book gives a sense of the quality of our "champagne"—I hope it will incite an urge to savor it firsthand.

—James H. Billington
The Librarian of Congress

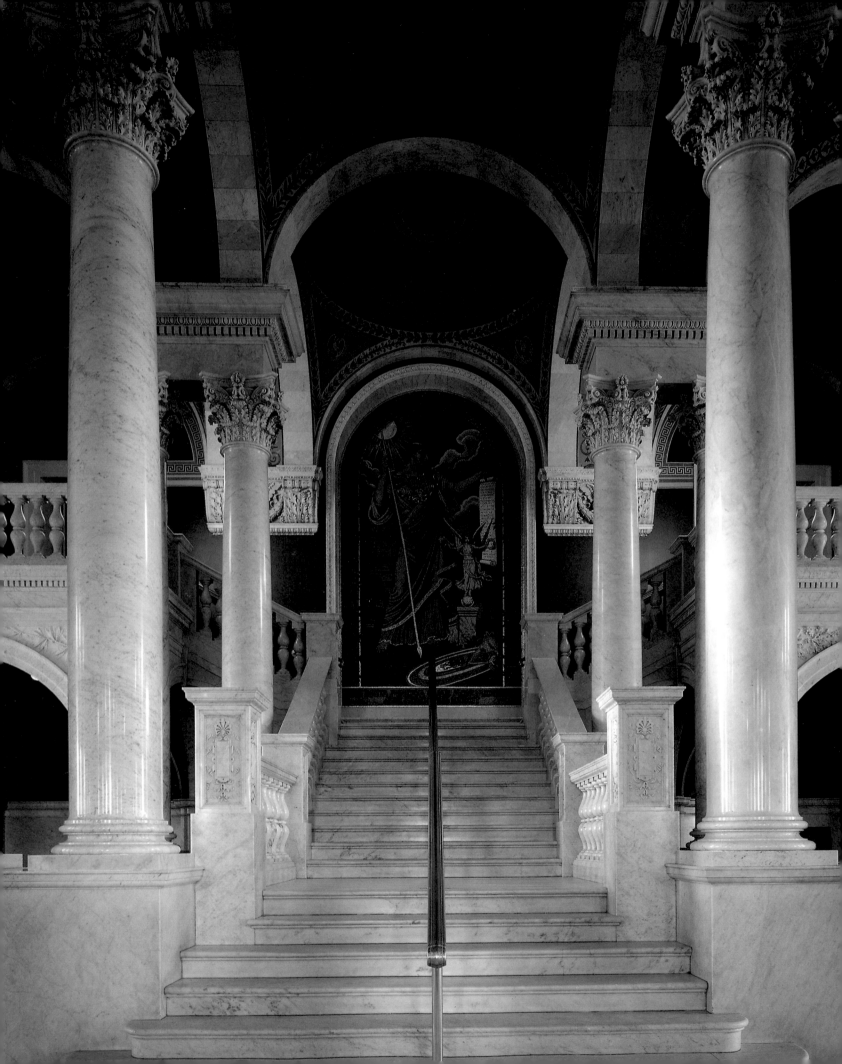

INTRODUCTION

The world's greatest universal collection of human thought and creativity resides under three roofs along busy Independence Avenue in Washington. All of the soaring metaphors about the Library of Congress ring true: treasure house, time capsule of the ages, multimedia encyclopedia, rearview mirror on civilization, vanguard of the information revolution. We call it simply "America's Memory," even though three-fourths of its more than 20 million books are in 460 languages other than English. This is fitting for the national library of a dynamic multicultural democracy. From a handful of books that arrived from London in 1801, the American people have built a collection of more than 105 million items—four-fifths in formats other than books.

If a childhood fantasy—the after-midnight stirring to life of inanimate objects—were to come true at the Library of Congress, centuries' worth of voices from every spot on earth would be heard laughing and cursing, playing music, sharing not just their wisdom and wonder, but also their simple thoughts and small fears and the uncensored accounts of humanity's accumulated sins.

The rationale for stuffing this storehouse so full of accumulated knowledge has often been expressed in the

Left: Elihu Vedder's mosaic of Minerva crowns the stairway leading to the Visitors' Gallery of the Main Reading Room. (Photograph by Carol M. Highsmith)

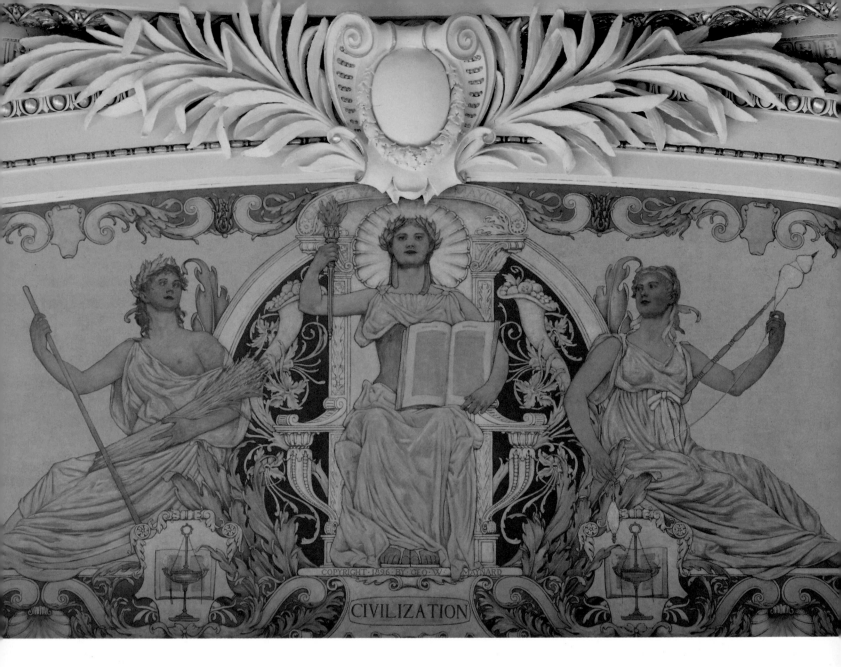

CIVILIZATION

Above: In the Pavilion of the Discoverers in the Jefferson Building, Civilization *sits between* Agriculture *and* Manufacture *in this painting by George Willoughby Maynard. Three other paintings in the Pavilion by Maynard represent three more elements of the Pavilion's theme:* Adventure, Discovery *and* Conquest. *(Photograph by Carol M. Highsmith)*

words of Thomas Jefferson, who said upon offering his personal library to the Library of Congress: There is "no subject to which a Member of Congress may not have occasion to refer." In today's world of global, interactive, electronic communications, there is no subject to which *any* American may not have occasion to refer—and no better place on earth to do it.

Congress's humble library loft in the U.S. Capitol evolved into the *nation's* library, thanks to steadfast congressional funding, gifts and purchases of private collections and the relentless copyright deposit of the fruit of

Americans' creative and intellectual toil. More than eight million new books, manuscripts, maps, films, compact discs, newspapers, periodicals and other items arrive at the Library's receiving dock each year. Just those *in arrearage*—the eighty-five thousand previously uncataloged items the Library is now whittling away each year— would stockpile a great world library. From that project alone have come forgotten letters from Mark Twain; Woody Guthrie's notes about his songs; entire Aaron Copland and Irving Berlin collections; the whole photographic morgue of the old New York *World-Telegram & Sun*; Joshua Logan Broadway playbills, posters and stage-set diagrams;

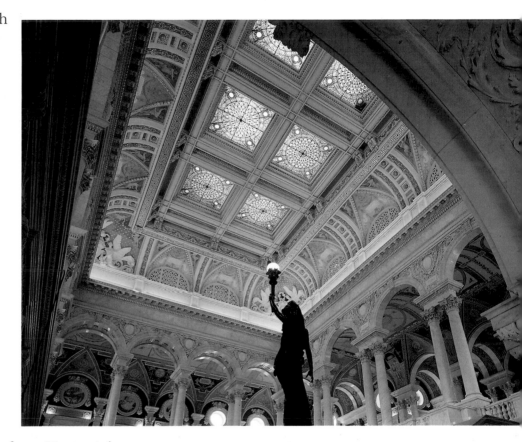

and a book of down-home recipes from Hope, Arkansas.

The First Continental Congress in Philadelphia had close access to a library, as did the original United States Congress in New York. When the national legislature moved to new quarters in Washington, books were one of the first comforts it secured. In the year 2000, the Library of Congress will begin a third century of service and inspiration, not merely to its 535 lawmaker bosses, but to every American who goes searching for information in Washington or who picks up his or her telephone at home, taps a few keystrokes and unlocks this national temple.

Above: This sculpture by Philip Martiny, student of Augustus Saint-Gaudens, stands at the foot of the Great Staircase in the Jefferson Building's Great Hall. Literary names like Dante and Herodotus appear in Frederick C. Martin's ceiling paintings beneath the refurbished stained glass. (Photograph by Carol M. Highsmith)

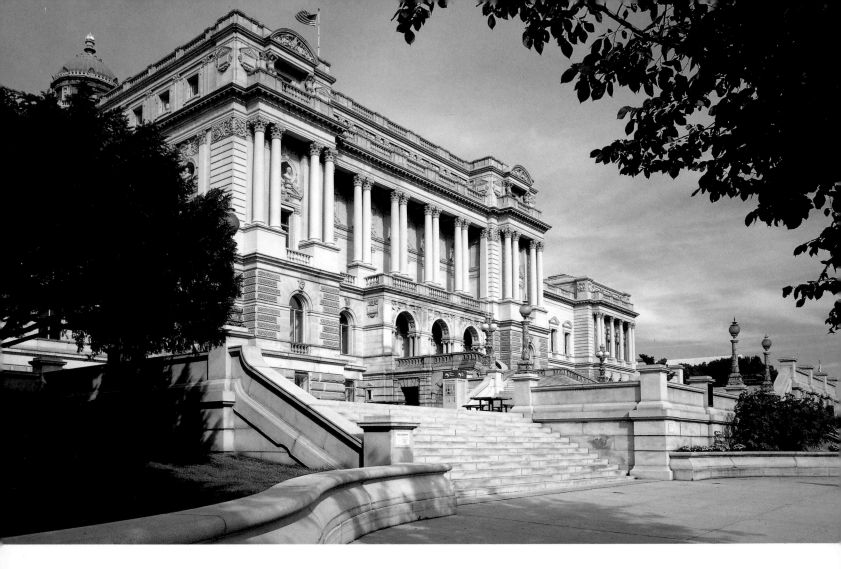

Above: The grandiose stairs and facade on the west side of the Jefferson Building typify the ornate work of construction superintendent Bernard R. Green, U.S. Army Engineer General Thomas L. Casey and his son, architect Edward P. Casey. The walls and buttresses of the building consist entirely of granite. (Photograph by Carol M. Highsmith)

But in the world of shriveling government resources, as Librarian of Congress James H. Billington told his staff in 1992, the "hard fact … is that the Library of Congress will not be able to sustain even its historic core of collections and staff unless it can find new ways to prove itself useful to the nation and thereby secure greater public recognition and support." Hence the Librarian's commitment to "get the champagne out of the bottle" and onto America's intellectual picnic tables by shedding the vestiges of its insularity in preparation for an electronic "library without walls." While it fixes one eye on the past, it has resolutely trained the other on the future.

In the twenty-first century, the Library of Congress will be challenged to bring order and sense to the

Firsts, Biggests, Bests

The wonders of the Library of Congress never cease.

More than seven hundred thousand researchers visit its Washington complex each year, and the Library responds to nearly 1.5 million requests for information from across the nation. Its automated bibliographic files, containing more than 12 million records, are provided free to anyone, anywhere, who can punch up the Internet.

Shoved side-by-side, the Library's 535 miles of shelves would stretch from Washington to St. Louis.

Its James Madison Memorial Building is the world's largest library building.

The Library of Congress holds the smallest known book on earth—a Scottish *Old King Cole* no bigger than a termite— the earliest surviving copyrighted motion picture, one of the first three books ever printed with movable metal type, the world's largest assemblage of a single musical instrument (1,650 flutes), the largest collection of television programs and the largest-known public collection of 78-rpm records—more than five hundred thousand discs.

The Law Library is the world's largest, as are the Library of Congress's collections of maps, newsreels, sheet music, personal papers and Arabic holdings. Its Asian collections are the largest in the Western world.

The Whole Booke of Psalms, *or the Bay Psalm Book, was published in 1640 in Cambridge, Massachusetts. The first book published in what would become the United States, this is one of eleven known copies. The Rare Book Division's American Imprint Collection holds approximately seventeen thousand books published between 1640 and 1800. (Photograph by Carol M. Highsmith)*

Its "firsts" include the first book printed in what is now the United States (the Bay Psalm Book), Alexander Graham Bell's first drawing of the telephone, the earliest photographs of the Capitol and the Wright Brothers' historic flight, the first comic strip ("The Yellow Kid") and the world's first cookbook, dating to the fifteenth century.

Rarities include Thomas Jefferson's copy of *The Federalist,* in which he names the "anonymous" authors; radio scripts by W. C. Fields, Mae West and Fred Allen; J. Robert Oppenheimer's papers on the atomic bomb; the guidebook to Berlin used by a young Austrian visitor, Adolf Hitler; Harry Houdini's scrapbooks; a collection of early playing cards; recordings by Kaiser Wilhelm II, Sarah Bernhardt and "Buffalo Bill" Cody; maps inscribed on powder horns and a pocket-size globe collection; a second-century papyrus fragment of Homer's *Iliad;* and an original rough draft of the Declaration of Independence, in Jefferson's hand.

Each user of the Library's service to blind and physically challenged readers receives an average twenty-nine braille and/or audio books and magazines annually, far exceeding the reading level of the sighted public.

worldwide information glut, to turn artifacts and electrons into wisdom while pleading for enough resources to serve its many masters: the American people, Congress, other federal agencies, the creative and library communities, scholars and the blind and physically challenged.

The Library's treasured tradition of openness is also a tall order. "One of my hopes when I came to the Library [in 1975] was that it should be an open place," Librarian Emeritus Daniel J. Boorstin told the authors. "The big bronze doors to the Great Hall were closed when I came. I had them opened, and it was objected that it would cause a draft. I said that was exactly what I wanted." Staggering losses to theft and vandalism subsequently put an end to direct public access to the bookstacks—underscoring the urgency of opening them as wide as possible in electronic form. Although the Library of Congress is a research library of last resort rather than a traditional public library, reference librarians are eager to assist, and everyone from schoolchildren to prisoners who calls or writes is helped (although children under eighteen are not allowed in the Reading Rooms). As one division chief puts it, "We never say, 'Don't come,' because you never know when you might be keeping an Einstein out."

One day the gifted lyricist Ira Gershwin visited the Library of Congress, to which he and his brother had donated their works. Inside Boorstin's office, he stopped to sign the visitors' book.

"Shining star and inspiration," Gershwin wrote, "worthy of a mighty nation."

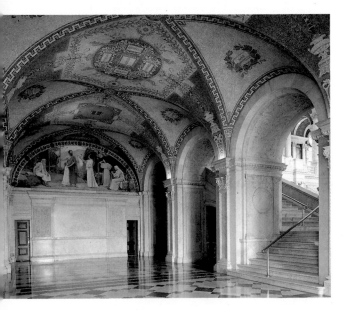

Below: Family *by Charles Sprague Pearce lights up the North Corridor of the Jefferson Building's Great Hall. The doors beneath the painting formerly led to the Librarian of Congress's suite, now located in the James Madison Memorial Building. (Photograph by Carol M. Highsmith)*

Antiquity's Jewel

In depth, universality and service to scholars, the Library of Congress has been compared to the magnificent Alexandrian library in Egypt. Named for and founded by the Macedonian conqueror Alexander the Great three centuries before Christ, Alexandria, with its giant harbor lighthouse—one of the Seven Wonders of the World—was the maritime crossroads of the ancient world.

Under its Macedonian Greek rulers, the Ptolemies, Alexandria became antiquity's most celebrated intellectual crossing as well. Its great library, created by Aristotle's pupil Demetrios of Phaleron, housed hundreds of thousands of papyrus scrolls containing the great Greek plays and Homeric poems, Greek translations of the first five books of the Old Testament and works from Persia and beyond. The library was part of a larger Mouseion (museum, or temple of the Muses) that convened great seminars of astronomers, botanists, poets, philosophers and mathematicians.

Just as today's Library of Congress uses copyright deposit to fatten its collection, Kings Ptolemy I and Ptolemy II used what might be termed "maritime deposit" to build theirs: They simply confiscated every scroll aboard ships that docked at Alexandria. Clerks copied the originals, kept them and delivered the transcripts to the captains. Just as Thomas Jefferson's great library formed the core of Congress's library, Aristotle's personal library enriched the Alexandria collection. The Alexandrian library, too, had a classification system; its scrolls were stored in marked niches carved inside walls. There was one big difference, though: The Alexandria facility was strictly a private collection.

Not a building or scrap of papyrus is known to survive from this great trove, which, midway in its six-hundred-year existence, shifted with the rest of the Hellenistic world to Roman administration. The complex was torched inadvertently by Julius Caesar during the attack and eventual assassination of his rival Pompey at Alexandria in 48–47 B.C. Some of the writings survived that fire, and the library was partially replenished by the Ptolemaic ruler Cleopatra VII. But pillaging by later Roman rulers, Christians outraged at its pagan holdings and Arab caliphs who reclaimed northern Egypt, destroyed every shred of the literary temple.

With help from UNESCO, the government of Egypt is creating a new Library of Alexandria, to be dedicated to the culture of the Mediterranean basin and filled with precious medieval manuscripts transferred from Egyptian mosques, museums and monasteries. When it is completed early next century, it is expected to hold eight million books. This Alexandrian library will be open to all comers.

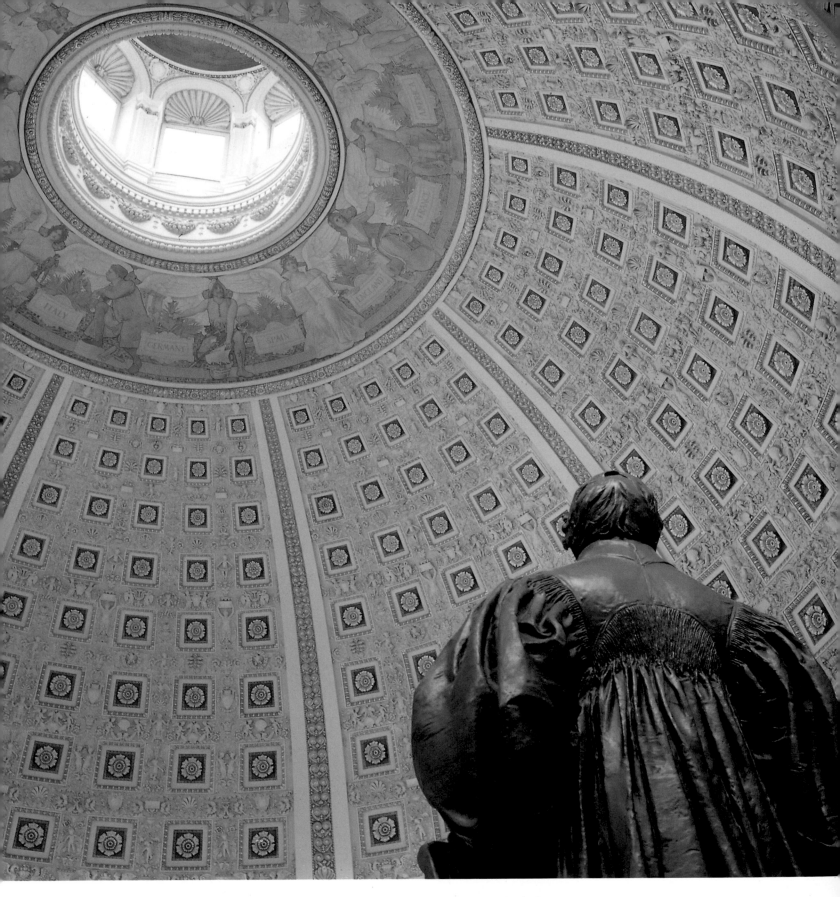

Above: The Main Reading Room Dome viewed from behind a statue on the balus-trade of the Rotunda galleries. Sunlight filters through the lantern of the dome, around which runs a mural by Edwin Howland Blashfield depicting twelve figures that represent countries or ages deemed to have influenced America's formation. (Photograph by Carol M. Highsmith)

CHAPTER 1

Magnificent Obsessions

Congress needed a library in the worst way when it moved from erudite Philadelphia in 1800 to the miasmal bog known as the District of Columbia. Members used to borrowing a classic or a British law book from one of Philadelphia's literary clubs found no such institution near their new chambers on Jenkins' Hill above the brambled paths, coarse taverns and uncivil rooming houses along the Potomac River. Little wonder they turned to a London bookseller to purchase, for five thousand dollars, their first collection of 152 works in 740 volumes plus three maps, which arrived in 1801. Fortunately William Thornton had included in his plans for the U.S. Capitol Building a library "apartment" in which to house them all.

Librarians of Congress—appointed, oddly enough, by the president rather than the legislature—at first were either promoted clerks of the House or the chief executive's political minions, the latter even including a physician, John G. Stephenson, selected by Abraham Lincoln. Later select-ees had some library experience or were renowned schol-ars, but only one, Eisenhower appointee L. Quincy Mumford, has held a professional library degree.

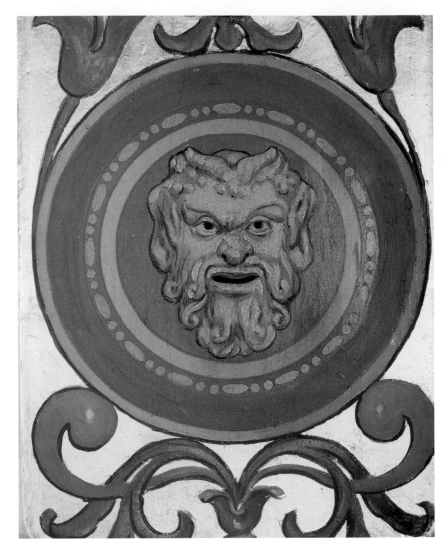

Right: This detail of Poseidon from an ornamental wall painting can be found in the Southwest Gallery of the Jefferson Building's Great Hall. (Photograph by Carol M. Highsmith)

Twice Congress's collections would be nearly obliterated by fire. British soldiers burned the Capitol during the War of 1812, destroying much of its library, though tales of gleeful Redcoats using the Library's three thousand volumes to kindle the blaze are exaggerated. Thomas Jefferson's personal library of 6,487 works, sold to Congress for $23,950 in 1815, would restock the Library over his political opponents' objections that his collection was needlessly large, "too philosophical" and had too many French and other foreign-language books. Jefferson's library arrived in a procession of "ten waggon loads" and was stored at Blodget's Hotel until a new library loft could be readied.

Two-thirds of Jefferson's books—indeed, two-thirds of *all* the Library's fifty-five thousand volumes—later went up in smoke in 1851 when a fire that started in a chimney flue invaded the library room above. This time, gifts and a congressional appropriation more than refreshed the collections—and the library apartment was replaced by a space that was said to be "the largest room made of iron in the world."

The collection remained manageable until the great copyright law of 1870—requiring the submission of two copies of new works by those seeking copyrights—plus the acquisition of forty thousand volumes from the Smithsonian Institution Library in 1866 so inundated the Library that even its two new wings were quickly piled high with uninspected books, maps and manuscripts. To worsen matters, in 1867 the energetic Librarian Ainsworth Rand Spofford talked Congress into buying, for $100,000, its first large private collection since Jefferson's—22,529 books, one thousand rare maps and other materials relating to early U.S. history from Washington publisher Peter Force.

The purchase instantly made the Library of Congress America's largest library.

Spofford began a long and skillful campaign to find new quarters, at one point sitting through a hearing in which it was suggested the burgeoning collection might be accommodated simply by raising the Capitol dome sixty feet. Finally in 1886, President Grover Cleveland signed a bill authorizing construction of the first separate Library of Congress building. It would take eleven years for what the Library's *Quarterly Journal* would one day call a "monument to civilization"—a marble-and-stone Italian Renaissance temple, topped by a two-tiered golden dome and

Right: The vaulted ceilings of the South Corridor of the Great Hall furnish a perfect canvas for the ornate paintings of the artists commissioned by the Library's designers. (Photograph by Carol M. Highsmith)

filled with fabulous sculptures and carved paeans to the classics—to rise just to the east of the Capitol grounds.

Since the Library had been twice burned, planners were thrice shy, so this edifice was to be "fireproof"; no wood was to be employed anywhere in its construction. After winning a design competition, architects John L. Smithmeyer and Paul J. Pelz tried and tried again to get final congressional approval, at one point submitting drawings for a building that better resembled a Gothic church than a library. Eventually they got the go-ahead on the Italian look, only to be fired (Smithmeyer in a dispute over foundation cement).

A Temple of the Arts

Swooning in the fervor of the Cities Beautiful movement at home and nationalist chest-thumping abroad, Congress authorized six million dollars not just for a library, but for an opulent shrine—heavily skewed to the *American* contribution to knowledge. Fresh from completing the Washington Monument and what is now called the Old Executive Office Building next to the White House, engineer Casey and superintendent Green outdid themselves on the Library building. They commissioned sculptors to fill the great entrance hall and octagonal reading-room rotunda with bronze symbolic statues, granite busts and epic paintings. Giant lunettes, Pompeiian panels, bas-reliefs and, out front, an extravagant Neptune fountain were but a few of the lavish decorations that Green commissioned. Stucco eagles, sea horses, griffins and other creatures looked down upon eight plaster statues symbolizing science, law, poetry, philosophy, art, history, commerce and religion—and sixteen bronze portraits of men like Michelangelo and Columbus who represented these pillars of civilization. Tributes to Americans, some obscure to today's visitors, fill the halls. All of the idealized images revere self-improvement and national destiny.

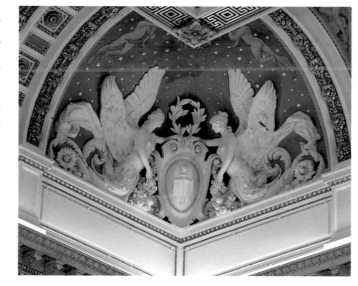

Philip Martiny's angelic figures holding book-bearing cartouches grace the corners of the Great Hall ceiling. The figures floating amid the stars were painted by Frederick C. Martin. (Photograph by Carol M. Highsmith)

Night and day for eight years, artisans on *revolving* scaffolds plastered, coffered and installed ironwork and a great marble staircase. The floors were marble, too; in fact, Librarian Spofford boasted that the edifice had "more marble in it than any building in America." Even Green's metal bookshelves and the structure's two thousand windows received classical ornamentation.

To awestruck visitors, the message was clear: The United States had *arrived.* It is little wonder that the Library of Congress Building, dedicated in 1897, renamed for Thomas Jefferson in 1980 and completely refurbished to mark its centennial, is as much of an attraction as the literary treasures it holds.

ANNEX TO JEFFERSON TO ADAMS

Although a distinguished man of letters, President John Adams, sandwiched as he was between the Father of the Country and the brilliant author of the Declaration of Independence, is somewhat of an afterthought in both America's and the Library's evolutions. It took the Library of Congress forty-two years after its first annex opened in 1938 to name it after Adams—and only then after the building had borne Jefferson's name for four years. The switch took place in 1980, when the original Main Building assumed Jefferson's name.

As usual, overcrowding prompted construction of the annex; two of the Main Building's four courtyards had been usurped for bookstacks, and a third for the Coolidge Auditorium. The white-marble, art deco annex contained twice the stack space of the old building and was soon filled to its 12-million-volume capacity. Although the building's exterior and hallways are largely unadorned, the Adams Building's two spacious reading rooms are beautifully ornamented, the north with Ezra Winter's paintings depicting Chaucer's Canterbury pilgrims, and the south ringed by Winter's murals saluting Jefferson. The annex was connected to the Main Building by a tunnel and a labyrinth of pneumatic tubes that sped "call slips" and messages between buildings.

An energetic team—construction superintendent Bernard R. Green, General Thomas L. Casey of the U.S. Army Engineers and a replacement architect (conveniently, Casey's son, Edward)—took over. They raised the dome to 195 feet, coated it with twenty-three-carat gold leaf and topped it with a gilded Torch of Learning. So frugal were Green and the Caseys that they finished the job a half million dollars under budget and promptly plowed the money into artistic embellishments. The "New Library of Congress Building" was completed in 1897 at a cost of just over six million dollars, and eight hundred tons of books and materials were moved across First Street from the Capitol to fill it.

It was left to a fastidious new Librarian of Congress, Herbert Putnam, to transform this treasure house of cultural

nationalism into the nation's literary strongbox. Ainsworth Spofford's reward for his success in realizing a new library building had been a demotion to deputy librarian after a Treasury Department investigation that found the copyright accounts thirty thousand dollars short. Spofford was exonerated after it was determined that the absentminded librarian had stuck almost the entire thirty thousand dollars in uncashed money orders into books submitted for copyright deposit that promptly became buried from sight.

Putnam succeeded in prying away the historical archives of federal executive departments and saw to it that a new legislative reference service was placed in his domain. By 1939, when he retired after forty years on the job, Putnam had secured $1.5 million from Congress to buy retired scientist Otto Vollbehr's collection of fifteenth-century books, including a vellum copy of the Gutenberg Bible. He had also sent "field station" crews out to document the Depression and had won approval of an annex that would more than double the Library's shelf space. Putnam even got the U.S. Constitution and the Declaration of Independence hauled over from the Department of State; they would reside at the Library of Congress for thirty-two years before finally moving to the National Archives Building in 1953.

During World War II, these great national documents and other library treasures were spirited off for safekeeping at Fort Knox, Kentucky, and many other sites. The Library of Congress assumed new antipropaganda duties, and Librarian Archibald MacLeish—a poet and lawyer who initiated the first massive reorganization of the Library in the twentieth century, including the development of "canons of selection"—accepted the directorship of the wartime "Office of Facts and Figures" that kept

Above: Summer, *by Frank W. Benson, is one of the seasons represented in the South Corridor of the Jefferson Building's Great Hall. The ornamental work around the panel, and other such decorations throughout the building, were fashioned by anonymous artists under the direction of Elmer Ellsworth Garnsey. (Photograph by Carol M. Highsmith)*

official tabs on the war effort. MacLeish's successor, Luther Evans, sparked controversy by vastly increasing the Library's international holdings at a time when there were postwar jitters over a perceived worldwide Communist menace.

The next Librarian, L. Quincy Mumford, was no less controversial. He greatly expanded minority hiring and successfully blunted President John F. Kennedy's attempts to transfer the Library to the executive branch—sweetened by a promise to officially designate it the National Library of the United States. To make such a shift, Mumford protested, would endanger the smooth funding stream from Congress.

Although he was a tireless exponent of "The Book," historian Daniel J. Boorstin, who succeeded Mumford, ordered the first widespread deployment of computer technology throughout the Library complex, whose reading rooms typed out their last catalog card and went online in 1981.

James H. Billington, who left the Woodrow Wilson International Center for Scholars to take over the Library in 1987, embraced and expanded the idea of an electronic "library without walls," which he ordered tested through several pilot projects.

On April 13, 1993, the 250th anniversary of Thomas Jefferson's birth, Billington accepted the Library's symbolic 100 millionth acquisition—a collection of 745 watercolor paintings and pencil drawings by nineteenth-century American artist John Rubens Smith. True to his commitment to digitization, the Librarian remarked, "These works especially lend themselves to dissemination through electronic means." The next item to be acquired was the first printed account of Portuguese explorations of the coast of Africa, which the Rare Book Division had sought for nearly seventy years.

Snatched from the Jaws of Congress

As early as 1783, Virginia delegate James Madison recommended that the Continental Congress build a library composed of books "proper to the use of Congresses." Although he was chief recorder of the Constitutional Convention and a framer of the Constitution and the Bill of Rights, Madison had no monument in Washington until the Library of Congress opened its third and largest Capitol Hill building in 1980. The modern $120-million, 2.1-million-square-foot structure—third-largest building in Greater Washington, after the Pentagon and FBI Headquarters—became Madison's "living memorial," the new home of the Congressional Research Service and the repository of more than 75 million items in the Library's map, film, photography and other special-format collections.

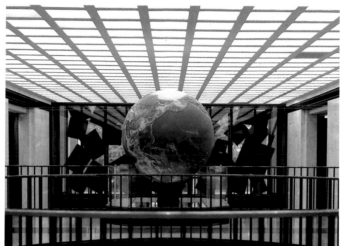

A gift of Andrew McNally III, chairman of Rand-McNally, the globe in the James Madison Memorial Building reflects the multicultural and multinational nature of the Library. While focusing on the literature, culture and history of the United States, the Library also holds important international collections. (Photograph by Carol M. Highsmith)

Critics called its squarish architecture "the box that the Rayburn [House Office] Building came in." But it saved the Library five million dollars a year in rent that it had been paying to house its overflow departments; the Copyright Office, for instance, had been operating out of a Virginia office building.

Filling six floors above ground and three below, the Madison Building gobbled up the last two available blocks on Capitol Hill at a time when Congress was casting about for space for an additional House office building. In 1975, when the Madison Building was 95 percent complete, House leaders brazenly proposed taking it over and plopping a new library building somewhere else. But fanned by cries of outrage from Librarian Daniel Boorstin, constituents across the country deluged their representatives with protests. Newspapers like the Jacksonville, Illinois, *Courier* called the land grab "Congressional piracy." U.S. Senator William S. Cohen of Maine termed it "an insensitive act of greed." The House leadership backed down and found a place for its new offices elsewhere.

The man who had first supported a legislative library was memorialized in a hall off the Madison Building's lobby. It features Walter Hancock's heroic statue of the fourth president, who is also remembered in carvings and bronze medallions elsewhere in the building.

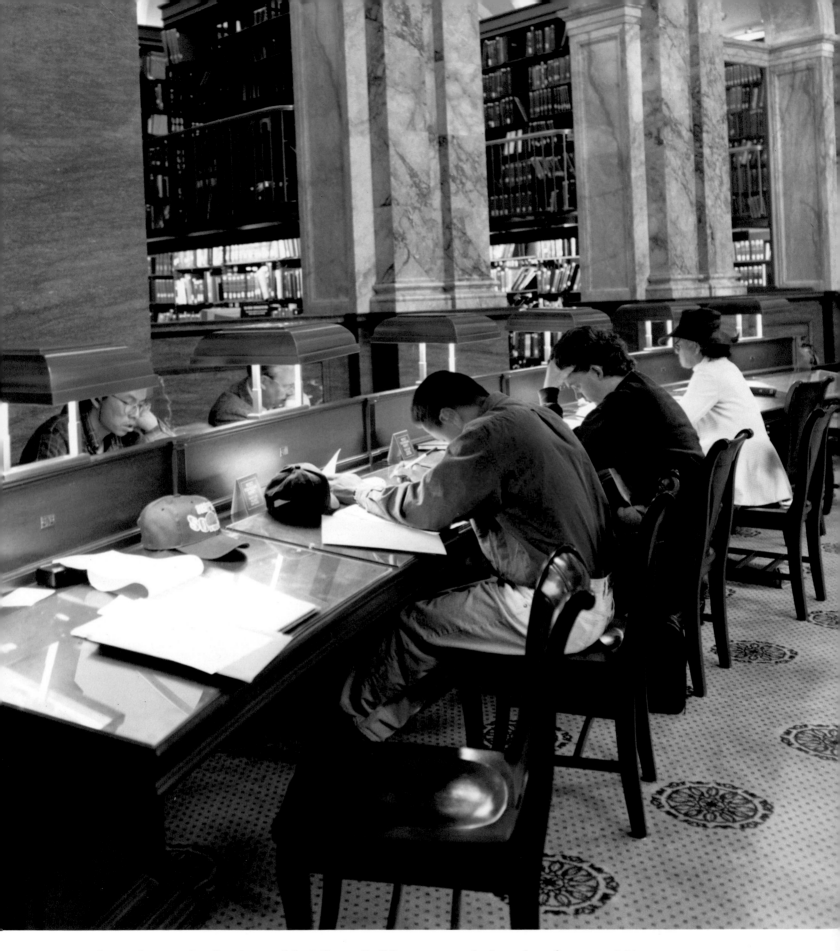

Above: The Main Reading Room of the Jefferson Building serves as the home base for many visiting researchers. The room provides light, desks and an inspiring dome beneath which students, writers, members of Congress and curious visitors may delve into the Library's treasures. (Photograph by Carol M. Highsmith)

CHAPTER 2

\mathcal{B}ooks

The Library of Congress may be, as Librarian Emeritus Daniel J. Boorstin described it, the world's most dazzling "multimedia encyclopedia," but the book—more than 20 *million* books—the most enduring connection among civilizations across the centuries, remains the heart of the collection.

From the reference desk in the Jefferson Building's Main Reading Room, epicenter of the Library's bookstacks, all things radiate. It is the user's compass, pointing toward specialized collections in other formats, 25 million old catalog cards in twenty-four thousand drawers, twenty-one other reading rooms and—via the Library's computer database—millions of holdings that have come in since 1969. Periodic surveys have shown that an overwhelming majority of Main Reading Room users successfully manipulate the online bibliography, get their reference questions answered and are able to study comfortably. Fifty-eight percent of users identify themselves as college students or faculty; another 20 percent report they are visiting on "personal research." A surprising 52 percent say they use the Library of Congress at least once a week.

Above: Ezra Winter's paintings of the pilgrims from Chaucer's Canterbury Tales *enliven the north reading room of the Adams Building. In this detail, Chaucer himself is seen turning around. (Photograph by Carol M. Highsmith)*

Without guidance, researchers could easily be overwhelmed. A search for information on "Navajo Indian blankets," for instance, seems straightforward enough, until the student is asked whether the focus is on blankets as an art form, an economic base, a historical artifact or even on "how-to" information on weaving. Where does one start in the database? "Blankets"? "Navajo"? Some other heading? Central desk librarians are the best navigators.

The Library of Congress collects almost every kind of book, from the Chipper the Rabbit children's series to Chaucer's *Canterbury Tales*, even to some of the more outrageous or pornographic contemporary works. But it's a fallacy that the Library owns one copy of every recent book written in the United States. It does not, for example, collect textbooks below college level or most vanity press

*I*NCOMPARABLE *E*XOTICA

The Library of Congress has isolated an astounding array of thematic collections, arranged by topic area or genre (for example, the *Little Big Book* children's collection), by historic individual (Sigmund Freud Collection) or by donor's name (the Otto Vollbehr Collection, which includes the Library's single most famous holding, a 1456 Gutenberg Bible, one of four surviving complete copies of the first book printed on vellum with movable type in the western world).

- 1,596 *miniature books* ten centimeters or less in height
- 272 titles from the personal library of feminist *Susan B. Anthony*
- More than ten thousand items from the collection of escape artist *Harry Houdini*—many of which relate not to stagecraft or magic, but to his passion for exposing fraudulent spiritualists
- 285 early works attributed to *Martin Luther*

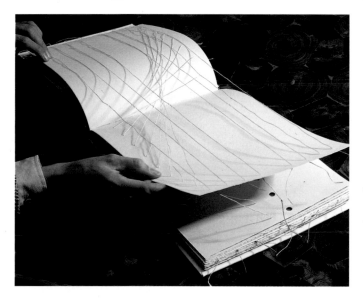

This "string book," created by contemporary artist Keith Smith, stretches the notion of book-as-printed-text: Instead of following a written story, the "reader" follows strings that shift into suggestive patterns as they travel through the pages. Not knowing from page to page what form the strings will take produces a sense of curiosity and suspense not unlike that created by a good novel. (Photograph by Carol M. Highsmith)

Other divisions also collect in this way, as in Millard Fillmore's personal collection of maps; the archive of both Major Bowes's and Ted Mack's "Amateur Hour" on audio tape, recorded disc and television kinescope; George and Ira Gershwin's music, papers and record collections; and an array of Woody Guthrie recordings and papers. Among the wide-ranging holdings in the Rare Book and Special Collections Division are:

- 277 pulp-fiction titles, including *Weird Tales* and *Amazing Stories*
- 254 books on hunting and natural history once owned by avid outdoorsman *Theodore Roosevelt*
- More than one thousand titles from the libraries of the leaders of Germany's *Third Reich*
- 6,700 examples of *World War II propaganda* by all sides during the conflict
- 2,600 books from the libraries of the *Russian Imperial Family*

publications deemed not to have research value. Many technical, agricultural and medical works are sent to specialized federal libraries. A small staff reviews the two copies of books that come in for copyright deposit and either keeps both or retains only one, saving the second for exchange with other nations or other libraries. Sometimes neither copy is chosen.

Why does the Library of the *United States* Congress— and the American people—collect so many works from abroad or published here in foreign languages? Remember Jefferson's phrase about Congress and its possible interest in any subject from any place or time. Many researchers are fluent in a number of languages, and there is no way to know what parts of a shrinking world, or even what language, will fascinate scholars a century or more from now. As a result, the Library of Congress has a stronger book collection on a number of the world's smaller nations than they do themselves.

One of the Library's traditional scourges—insufficient stack space—was only partially relieved by the addition of the James Madison Memorial Building in 1981. It gave blessed relief to scattered specialty divisions but added few bookshelves. As a result, the Library of Congress is gradually moving more than two hundred and fifty thousand little-used books and excess special collections material to remote storage off Capitol Hill, where they will still be accessible to researchers following a longer waiting period.

Although new entries into the Library of Congress catalog are now entirely computerized, the Library continues the practice, begun in 1901, of producing catalog cards and selling them to other libraries. It also indexes and assigns "machine-readable" catalog information to

thousands of books *before* publication, so that local libraries, when they receive new books, have ready-made listings printed on the back of the title pages and can get them on the shelf immediately.

Books that you won't find in your local card catalog, and cannot borrow from the Library of Congress through interlibrary loan, are the more than 650,000 items in the Rare Book and Special Collections Division. These materials are available to serious researchers over eighteen years old in the

Below: This wide array of books from the various collections of the Rare Book Division includes Walt Whitman's copy of Henry David Thoreau's A week on the Concord and Merrimack Rivers; *Thoreau's copy of Whitman's* Leaves of Grass, *given to him by the poet;* Mein Kampf *by Adolf Hitler; Harry Houdini's copy of* Hocus Pocus Junior *(published, 1635); and Susan B. Anthony's copy of* Aurora Leigh *by Elizabeth Barrett Browning. (Photography by Carol M. Highsmith)*

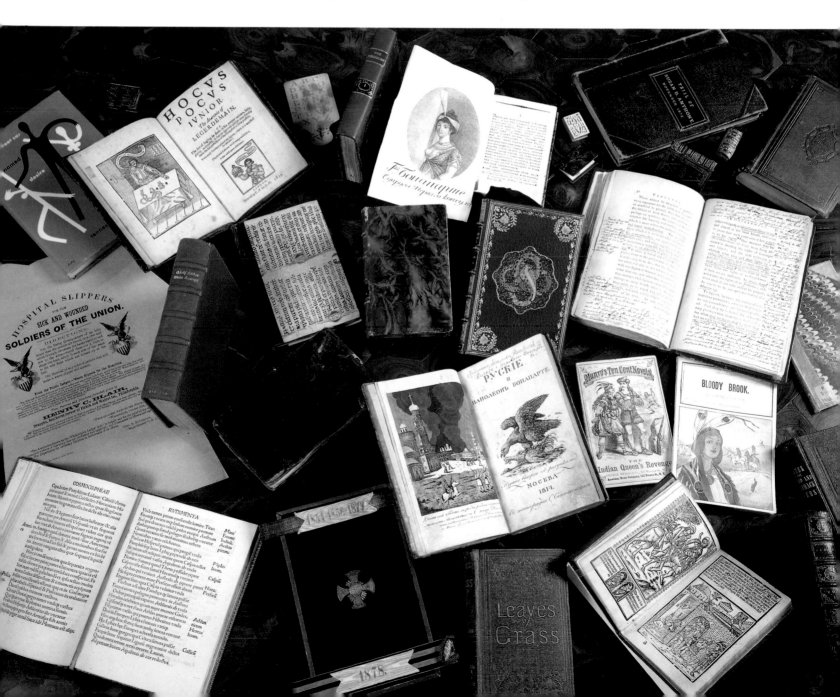

Rare Book Reading Room, modeled after Philadelphia's Independence Hall. Not all are books. There are, for instance, medieval and Renaissance manuscripts. The collection also includes more than fifty-seven hundred books produced during the first fifty years after the printing press was invented.

Just what is a *rare* book? It's a manageable question when you're dealing with Aristotle, Shakespeare or Euclid—more difficult the closer one gets to contemporary times. The lighthearted definition is that a rare book is any volume one wants and cannot get! But the Rare Book Division operates within a broader definition: It is one that will have long-term scholarly value, usually a book whose complete text or binding, incomparable illustrations or unusual format or style of typography are important to preserve. Thus the Rare Book and Special Collections Division makes few demands on the Library's microfilming staff. No piece of microfilm or digital printout can duplicate the experience of holding a centuries-old book. A volume like the Eliot Indian Bible—the first Bible printed in what is now the United States—can be held, and its pages turned, as readers of 1663 turned them. That's one reason that researchers are generally not asked to wear clumsy white gloves.

Because tastes change over time, mundane literature can become rare. For instance, the Library of Congress began setting aside provocative books by and about women long before women's studies became a subject of general interest. Conversely, it also has a fine collection of authors like the early twentieth-century novelist Hugh Walpole, even though there's rarely a call for Walpole today. Who's to say, the curators remind us, that he won't be extensively studied generations from now?

Mr. Jefferson's Collection

The Library of Congress came by its eclectic reputation honorably, for the 6,487 volumes from Thomas Jefferson's personal library that instantly doubled the size of Congress's collection after the British burned the Capitol the previous year were as diverse as Jefferson's insatiable mind: books in seven languages (including Russian), on art, law, architecture, government; Holy Bibles and a Koran; even a book on harpsichord fingering techniques. Congress wanted only his law books, but Jefferson insisted that it take all or none. The lawmakers relented and paid him $23,950.

You can reach into the twenty-five hundred or so that survived the Library of Congress fire of 1851 and pick out a slim volume of two pamphlets, bound together, of *Disputes Between Great Britain and Her American Colonies*, written in 1769 by Britisher Allan Ramsey. Leafing through it, you find "marginalia," penned with many exclamation points, taking heated issue with Ramsey's points. They were scribbled not by Jefferson, but by the man who had owned the book previously: Benjamin Franklin.

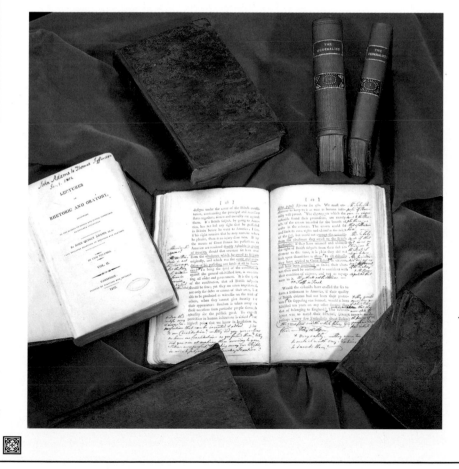

The Jefferson Collection reflects the intellectual interests of the great revolutionary, statesman and president. The sampling taken here includes bound lectures on rhetoric by John Quincy Adams (with an inscription from John Adams to Jefferson) and The Federalist, *with marginalia in Jefferson's hand identifying the anonymous authors. (Photograph by Carol M. Highsmith)*

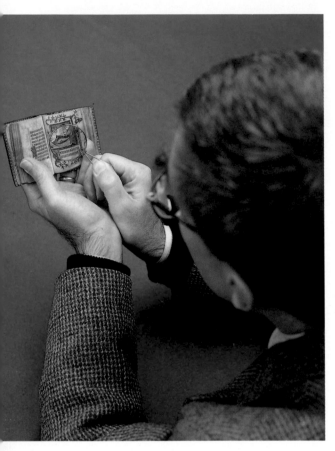

Above left: Peter VanWingen, a specialist in the Rare Book and Special Collections Division, holds a fourteenth-century French book of hours beneath a magnifying glass that accompanies the book. The fine detail of this three-inch-tall illuminated manuscript would also have required a magnifying glass for its execution. Medieval Christians often followed this pocket-size book's prescribed prayers. (Photograph by Carol M. Highsmith)

Above right: Librarian of Congress James H. Billington examines an illuminated gradual chant, used in seasonal celebrations of the Mass, in the Southwest Gallery of the Great Hall. (Photograph by Carol M. Highsmith)

A few books that are not intrinsically or aesthetically special, but were curiosities likely to be stolen at the time the Library's general stacks were open, are included in the Rare Books collection. Some pornographic books and volumes like *The Marijuana Cookbook* fit this description. But most works in the Rare Book stacks, such as the Library's first piece of Americana—a 1493 Christopher Columbus letter describing his epic voyage of the previous year—are jewels by anyone's definition.

One reason the staff makes subjective judgments about which books to collect today for tomorrow's scholars is that the books are cheaper and easier to find now than they will be later. So the division's "recommending officers" hunt especially assiduously for books that will have long-term value.

Special Collections include books that came to the Library in a group, often through a benefactor's gift. Not every item therein needs to be considered "rare." Visitors might themselves own an equally fine original Dell paperback version of Joseph Heller's *Catch-22*, one for which a local book dealer would probably give them fifty cents. But the Library of Congress has, lined up in a row, the full run of seven thousand Dells, including seven different issues of *Catch-22*, all the gift of the Western Publishing Company of Racine, Wisconsin. Suddenly these common paperback books are transformed into a valuable archive of American publishing history.

A book's assessed price is only one factor in a decision to isolate it in Rare Books, but it can be a signal that a book deserves consideration. Library of Congress staffers are not allowed to assign values to books owned by the public, in part so readers won't bring in a "neat old book"

they picked up at a garage sale and ask for an appraisal. A brochure on what to look for and how to get an old book appraised, written by Rare Book and Special Collections staff member Peter VanWingen, is an agreeable alternative.

Several monographs have been written about the magnificent Rare Books and Special Collections of the Library of Congress. The holdings run a wide gamut: dime novels and pulp fiction, first-edition *McGuffey Readers*, James J. Audubon's *Birds of America* collection, three centuries' worth of American almanacs, early Bibles in numerous languages, Shaker literature, more than eleven thousand "Lincolniana" publications and the only known copy of Alexis de Tocqueville's *De la démocratie en Amérique* in its original paper wrapper. While posters, maps, photographs—and even a Charles Dickens knife, fork and spoon set—are also prized Rare Book and Special Collections holdings, it is the printed word that is venerated.

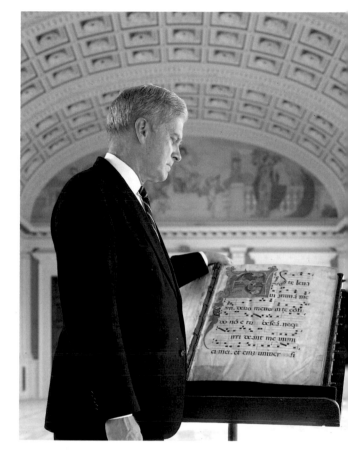

An Illustrious Donation

The nearly three thousand examples of the "illustrated book" in the Lessing J. Rosenwald Collection, including dozens of *incunabula*—works printed before 1501—rank as the Library's most resplendent collection. The Philadelphia library of this retired Sears Roebuck chairman, which has been recreated in the Jefferson Building, was packed with books gathered for the beauty of their illustrations as much as for their literary contents.

Rosenwald's books, most purchased singly over a fifty-year span, range from ancient Oriental xylography to landmark European volumes such as a 1543 first edition of Nicolaus Copernicus's *On the Revolution of Celestial Spheres*. The words of a 1465 volume of Cicero, for example, were printed in Mainz, Germany, on vellum—animal skin prepared for accepting ink. Scribes wrote out the large initial letters of each chapter in a sticky substance, applied gold dust, shook off the excess, then burnished the gold to a shine that truly does illuminate the volume. Elaborate illustrations accompanying the text were also painted by hand.

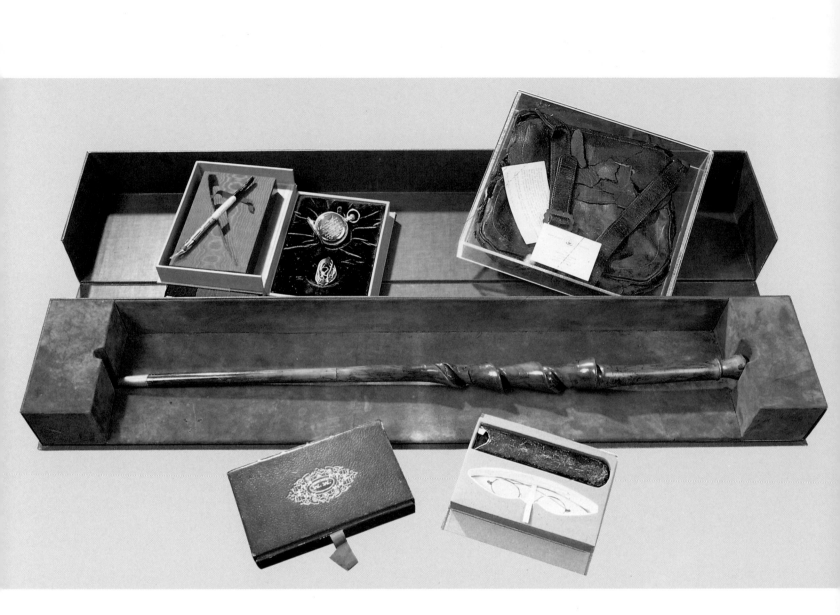

Above: The Library boasts the largest collection of items associated with the poet Walt Whitman (1819–1892), featuring more than twenty thousand manuscripts and many artifacts. Pictured here (clockwise from the upper left corner) are Whitman's pen, pocket watch, watch fob, the haversack in which he carried gifts to wounded Civil War soldiers, his walking stick made from a calamus root and his spectacles (the Feinberg–Whitman Collection in the Manuscript Division). (Photograph by Carol M. Highsmith)

CHAPTER 3

*F*rom *F*lutes to *F*oreign *P*olicy

More than any other library in the world, the Library of Congress is a time capsule of information in formats other than books.

Its ten thousand separate collections of 53 million manuscripts range from James Madison's notes on the secret deliberations of the Continental Congress to Booker T. Washington's papers, to a copy of Justice Felix Frankfurter's draft of the "With all deliberate speed" decree in *Brown v. Board of Education,* to the letter from Jehovah's Witness William Gobidas in the 1930s, explaining his refusal to salute the American flag. While most of the rest of the Library is worldwide in scope, the manuscript collection of one-of-a-kind documents has focused on the papers of individuals who have shaped the course of American history specifically, in the belief that foreign manuscripts are part of other nations' patrimony. One-tenth relate to the American Civil War.

The Library treats most manuscripts not as rarities, but as scholarly documents to be used. Many are brittle and crumbling, so the Manuscript Division aggressively micro-films its collection. Still, with few exceptions, the researcher

who has a demonstrable need to see and handle originals—say, someone investigating old watermarks—is served them. Several Pulitzer Prize–winning books have been based largely on the Library of Congress manuscript collection.

The Library's more than four million maps and fifty thousand atlases are literally global, yet also decidedly local, in scope. Most early maps were drawn less for navigation than to show the scope of a king's empire—and were affordable only to nobles and merchants. Nineteenth-century lithography made maps more accessible, and the advent of free road maps in the early twentieth century forever linked cartography and the common person.

Scholars use maps to trace the development of a culture. An 1882 map of Iowa, for instance, highlights railroads and towns lucky enough to fall along them. Sanborn fire insurance maps of many American cities from the 1880s to the 1950s describe urban growth, down to color-coded symbols for individual structures' uses and building materials. Topographic maps become hot property when trouble breaks out in heretofore obscure parts of the world. Maps that show vegetation help document deforestation, genealogists look for towns from which their ancestors migrated and modern detailed maps can help officials choose routes over which hazardous wastes can be safely carried. Satellite maps, and the Library's "geographic information system" databases, have uses that are only now being discovered. On computer-enhanced maps, researchers can literally change the appearance of a town by adding and removing buildings,

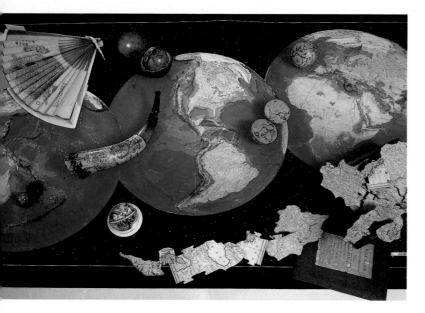

Below: The collection of the Geography and Map Division—containing more than four million maps—ranges from maps inscribed on powder horns to the latest topographical images generated by satellites. Several pocket-sized globes, a fan-map and map puzzle may be seen here with a powder-horn map on top of a contemporary map of the world. (Photograph by Carol M. Highsmith; world map by Raven Maps and Images, copyright © 1990)

changing highway routes, and making other projections useful in city planning. For those who simply enjoy a good road map, the Library has decades' worth for each state and county in the nation—and for most every corner of the world. And for those who appreciate craftsmanship, there are hundreds of globes—some the size of racquetballs—and maps carved on scrolls, fans and powder horns.

The map collection began as three maps and four atlases in 1800; it now includes more than four million items and gains more than fifty-three thousand new maps each year. Drawer after drawer of maps and charts in the Madison Building basement are especially valuable because of maps' impermanence; they are, after all, created to show the here and now—and here to there.

The 15 million items in the Library's Prints and Photographs Division also vividly record the passage of time and technique. They range from rare fifteenth-century chiaroscuro woodcuts to Mathew Brady's Civil War photographs to the latest *art moderne* prints. The Library selects and preserves its daguerreotypes, albumen prints, glass-plate negatives, snapshots, dry-plate negatives, cartoons and caricatures, old newspaper photographs and magazine illustrations, posters, contact sheets and slides and, of course, color and black-and-white photographs for their documentary, as well as artistic, value.

Below: From the collections of the Prints and Photographs Division, Timothy O'Sullivan's albumen silver print in 1873 shows the ancient ruins in the Cañon de Chelle, New Mexico. (Courtesy of the Library of Congress)

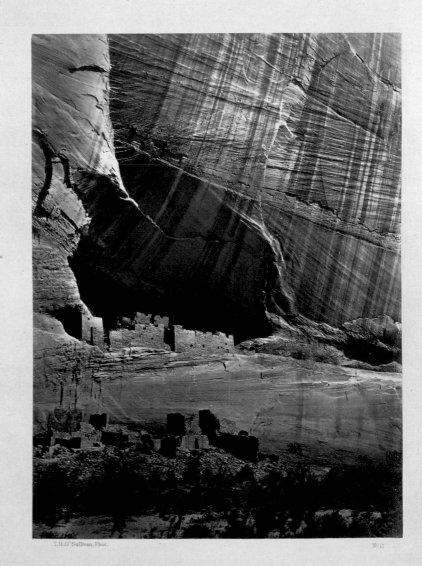

T. H. O'Sullivan, Phot.

ANCIENT RUINS IN THE CAÑON DE CHELLE, N. M.

In a niche 50 feet above present Cañon bed.

24

Among the division's remarkable special collections: 1.2 million images taken on assignment for the *U.S. News & World Report;* 164,000 Farm Security Administration (FSA) photographs of daily life during the Great Depression— including what some call an "unknown collection" of *color* FSA images that had languished in a refrigerated vault for thirty years; delicate Currier & Ives lithographs; turn-of-the-century stereographs; Brady's gallery of portraits; forty thousand blueprints and architectural drawings of Washington, D.C.; and the photographs of America's first renowned female photographer, Frances Benjamin Johnston. Historians have used the collections to depict the changing face of America, from its costumes to its road signs to its treatment of minorities.

The Prints and Photographs Division receives tens of thousands of items from copyright deposit, but it prefers to let them "rest a spell" before culling them, so as to gain historical distance. Appropriated congressional funds barely enable the division to fill in holes in its holdings; it aggressively documented the human toll of the AIDS crisis in the early 1990s, for instance, by purchasing the work of master photographers. But Prints and Photographs also enthusiastically seeks gifts and endowments, especially to build its collections of design and poster art, master prints and the drawings of prominent Americans like Frank Lloyd Wright.

Because of problems with fading, most color photographic images are kept in storage at the Library's Landover, Maryland, warehouse; early nitrate-based negatives are retained in another storehouse in Suitland, Maryland. But an astounding 2.5 million black-and-white items are kept within users' easy reach in the division's reading room.

Left: This print showing troops atop a signal tower at Elk Mountain, Maryland, overlooking the battlefield of Antietam in October of 1862, is representative of the Prints and Photographs Division's Civil War collections. (Courtesy of the Library of Congress)

Right: From the master prints collections of the Prints and Photographs Division, this sketch, Three Heads, *by Rembrandt Harmenszoon van Rijn, gives an indication of the diversity of the division's collections. (Courtesy of the Library of Congress)*

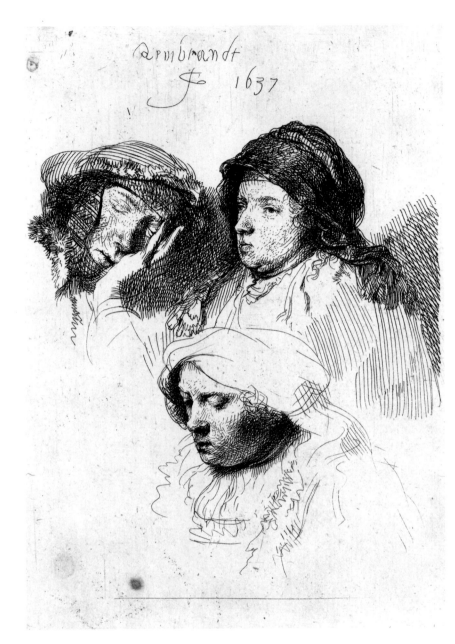

Prints and Photographs curators preserve their fragile collections through cold storage, aggressive use of digitization and by making interpositives (a positive negative of deteriorating negatives) and using them to make further copies. "Electronic servers" give users easy-to-browse, well-cataloged digital reference copies of images that can be "searched" across several separate collections before origi-

nal copies are ordered. Without such aids, scholars on a narrow mission must turn to the division staff for guidance.

Researchers hunting a newspaper or magazine article are also advised to check with a Serials and Government Publications Division reference librarian, since one of its managers, asked how many items were in his collection, shrugged, "How many gallons of water are there in the river?" The best count: fourteen hundred current newspapers from around the world, seventy thousand current magazines and journals and 1.6 million government documents. "We hang onto things that are made to be thrown," this manager noted. "You read a *Time* magazine or the daily paper and toss it. But how nice it is to be able to put your hands on an issue of *Time* from fifty years ago."

The Library of Congress collects not only the output of the U.S. Government Printing Office, but also other nations' official documents—even those of unfriendly nations—and the acts of all fifty state legislatures, plus state magazines like *Arizona Highways* and *Virginia Wildlife*. Back issues of newspapers are generally microfilmed, but the Library has retained full sets of seminal newspapers from the nation's early life, such as the *Virginia Gazette* and the *New England Courant*. Single newspaper editions that recount momentous events—assassinations, natural disasters, moon walks, wartime surrenders—are kept in hard copy as well. Old magazines, pulp fiction and comic books are bound and kept in the general collection. Periodicals librarians can tap into online indexes to more than a dozen leading American newspapers and fourteen hundred periodicals.

TRACES OF TROUBLED TIMES

Rarely if ever has a nation set out to record its contemporary culture with the zeal with which artists, writers, anthropologists and photographers took to the field to capture and *create* great art and literature during the Great Depression of the 1930s. Works Progress Administration (WPA) muralists decorated federal buildings, Civil Works Administration (CWA) photographers began documenting the nation's threatened architectural inventory, Federal Art Project artists created grittily optimistic posters and prints, the Federal Theatre Project staged uplifting plays, the Federal Writers' Project produced comprehensive guidebooks about every state and the Farm Security Administration sent photographers to hard-hit rural counties to record the human face of hardship. The harvest of these efforts can be found in poignant collections throughout the Library of Congress.

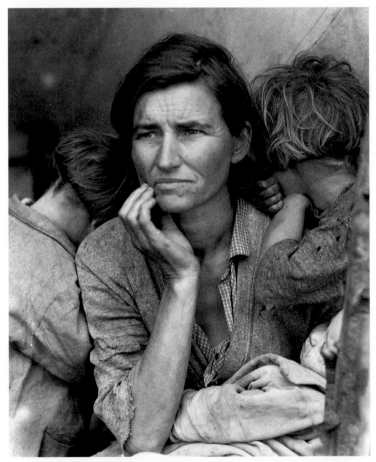

This Depression period photo, Migrant Mother, *by Dorothea Lange, is from the collections of the Prints and Photographs Division.(Courtesy of the Library of Congress)*

You can put a book, a magazine, an entire library's bibliography, even a photograph or presentable likeness of a manuscript or piece of sheet music on computer, but you can't send a 1704 Stradivari violin, or a Laotian bamboo mouth organ, or a glass flute once presented to James Madison winging down the electronic highway. Yet these and nearly eighteen hundred other musical artifacts are part of the Library of Congress music collections. Many arrived along with music manuscripts and books that donors did not want separated, and they're finding a new home in restored pavilions adjacent to the Coolidge Auditorium. That deliberately austere 511-seat theater in the Jefferson Building's northwest courtyard, built in 1925 with a grant from patron Elizabeth Sprague Coolidge, is world-renowned for its sublime acoustics.

Some of the instruments, most notably the Stradivari violins (three), viola and cello that were donated by Mrs. Gertrude Clarke Whittall, along with an endowment for a concert series, are regularly removed from their cases and played in Library of Congress concerts. Others, including several from among the 1,650 flutes and woodwinds of the Dayton C. Miller Collection or the one hundred brass and woodwind instruments of the R. E. Sheldon collection, have been used in special concerts and recordings such as "Our Musical Past".

But the bedrock of the Music Division is the collection of millions of musical manuscripts, printed scores, books about music and records of musical lives and creativity. The assemblage of Irving Berlin's personal papers and business records alone numbers about 750,000 items. So rich is the assortment of published American popular music that the Library in the early 1990s was still unboxing

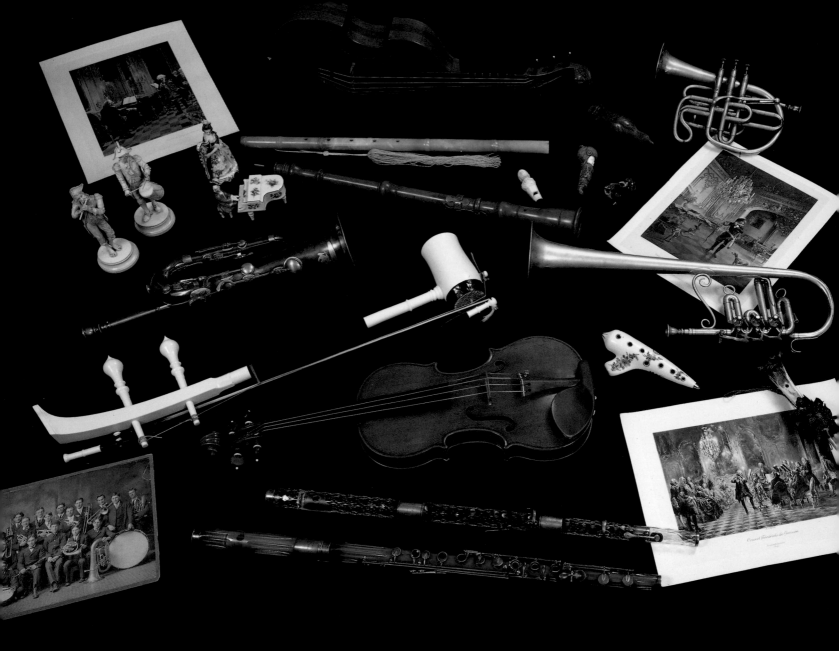

Above: This assortment from the Music Division's collection includes a Stradivari violin, a Siamese folk instrument, a photograph of an early twentieth-century college pep band, a keyed bugle from Boston, a seventeenth-century Chinese jade flute, early nineteenth-century musical statuary and a walking stick flute. The vast collections of the Music Division also contain sheet music, playbills and recordings. (Photograph by Carol M. Highsmith)

thousands upon thousands of pieces of nineteenth-century sheet music that came in on copyright deposit.

Along with esoterica like Victor Herbert's death mask and a lock of Beethoven's hair, the music embodies much social and cultural history. For instance, special music written to commemorate almost every event, from a Fourth of July picnic to the opening of a new baseball field, was published in the United States from the late nineteenth century until World War I and beyond. More than 120 songs were published about the "unsinkable" *Titanic* alone.

The range of the Music Division's more than five hundred special collections is breathtaking: autograph music manuscripts from medieval times to today; thousands of posters, self-portraits, correspondence and photographs of composers and artists; and a long paper trail of jazz and jazzmen. You'll find an American Harp Society repository; autographed manuscripts of John Philip Sousa, Richard Rodgers, Charles Mingus and Jascha Heifetz; the music and personal papers of Leonard Bernstein, Aaron Copland and Oscar Hammerstein II; Beverly Sills's forty-one scrapbooks; a Rachmaninoff archive; and the music America sang, from the Bay Psalm Book to today.

Musical treasures abound in the Library's bookstacks full of 2.3 million sound recordings as well. More than 80 percent are uncataloged, but the staff is adroit at using discographies, publisher catalogs and other finding aids to locate a certain song or performance. As is true elsewhere in the Library, the more specific the request, the better. "Please," asked a division manager, "don't come in and say, 'I'm looking for some dance music.'" Wax, vinyl and even rubber and glass records, compact discs, audio tapes and cylinder and wire recordings (there's even a collection of dictaphone belts containing practice versions of musical show tunes) are usually grouped by recording company, but curators have also pulled together songs about topical issues, people and events, such as abortion, the Persian Gulf War, First Lady Hillary Clinton, presidential candidate H. Ross Perot, even a gathering of steamships in Missouri. By no means may much of this be "good music," but someday these esoteric recordings may be highly prized in any case. How the Library wishes today, by way of example,

ROOTIN'-TOOTIN' TREASURES

In the last decades of the nineteenth century, a Cleveland, Ohio, physics professor, Dayton C. Miller, the son of a Civil War fifer, began to collect flutes, flutelike instruments (some little more than whistles), books on the flute, even paintings and bric-a-brac figures related to the flute. Shortly before his death in 1941, he donated it all—three thousand books, about ten thousand pieces of sheet music, 1,650 flutes and other instruments and assorted ephemera—to the Library of Congress. For a time, out of fear that Washington might become a World War II battleground, the collection was taken to southern Virginia and stored, still in crates, until war's end. The flutes themselves are made of gold, ebony, ivory, even glass, which—if one could keep from dropping the instrument—was prized because it would not warp or crack. More than two dozen flutes even double as walking sticks.

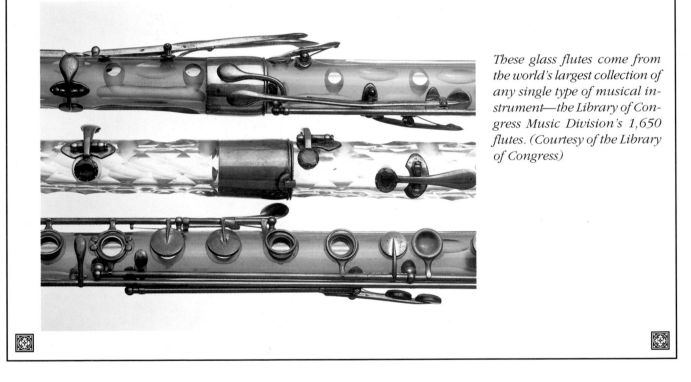

These glass flutes come from the world's largest collection of any single type of musical instrument—the Library of Congress Music Division's 1,650 flutes. (Courtesy of the Library of Congress)

that it had not turned down jazz collections offered in the 1920s that were not thought to be "serious" enough.

The Library's tapes and discs are not all musical. Its sound archives include cultural broadcasts from National Public Radio, the Voice of America and Armed Forces

Radio; about twenty-five hundred recordings of interviews with U.S. Marines returning from World War II combat in the Pacific; thousands of poetry and literature readings; and more than 175,000 sixteen-inch lacquer discs of NBC Radio programs from the 1930s through the 1960s.

Because there was no federal copyright law covering recordings until 1972—and many "alternative" record companies ignored the deposit requirement after that date—there are holes in the Library's collection. Thus it relies heavily on the kindness of collectors, who have formed worldwide networks by genre or artist—from Caruso to Jerry Lee Lewis. In 1993, for example, the division added 250,000 jazz 78s via a gift/purchase arrangement with a Long Island, New York, collector.

The public is not permitted to handle the Library's recordings, nor does the scarcity of staff permit leisure listening; a staff technician will play a selection for researchers working on a project leading to a publicly available work. Because of possible copyright conflicts, the Library will make copies of commercially recorded material only when proper authorizations are obtained.

The division must be an equipment museum of sorts as well, acquiring and maintaining not just recordings, but also fragile and arcane apparatuses, from cylinder machines to CD players, needed to play them. Old formats are preserved with great affection, since even laser technology has not succeeded in faithfully reproducing, or improving upon, originals.

The Library of Congress also conserves the earliest surviving motion pictures, plus thousands of files relating to their creation and distribution. Since there was no copyright

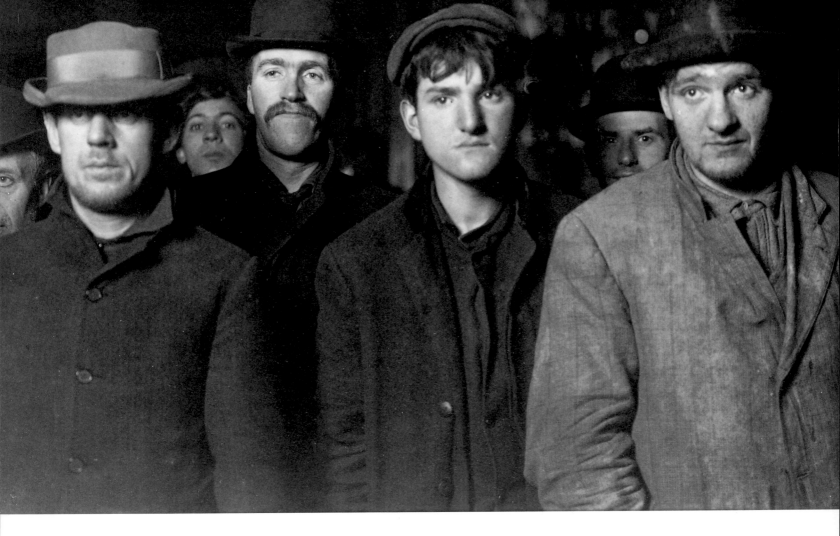

Above: From the collections of the Prints and Photographs Division, this 1907 photo by Lewis Hine, Bowery Mission Bread Line, 2 A.M., New York, *captures the gritty realism of a bygone era. (Courtesy of the Library of Congress)*

law covering films until 1912, early producers sent in negatives from each individual frame, from which contact sheets were made. These paper prints, including the earliest—an 1893 copy of W. K. L. Dickson's crude film of a boy tossing Indian clubs—were then strung together in strips up to a thousand feet long. The three thousand of these strips in the Library's possession were never meant to be viewed as a motion picture, but they have been turned into memorable footage such as that of the devastation that followed

the great San Francisco earthquake of 1906. Because most of these pre-1912 films that survive (at least 90 percent do not) came from the Edison and Biograph companies, it is the work of Thomas Edison and Biograph's Dickson and D. W. Griffith that are best known today.

Librarian Archibald MacLeish invigorated the Library of Congress motion picture collection in 1942—reactivating copyright deposit of films after print-oriented Librarians had not pressed filmmakers to send in their works. His original intent was a narrow one: to determine how Central and South Americans were being portrayed in motion pictures; had the portrayals been insulting, he feared, Latin American nations might be driven into the Axis sphere of influence.

Motion picture companies themselves discarded thousands of classic films through the years. Like the Big Three automakers, they were more interested in selling the latest model; one cannot order a 1957 Chevy today. Yet, as at least two oldies-movies cable channels attest, the appetite for old films has never been stronger. It was left to the nation's great film archives—including the Library of Congress—to latch onto films where they could. In the Library's case, more than 100 million feet of classic Hollywood films on black-and-white nitrate stock are stored in preservation vaults in Dayton, Ohio, where they are copied onto safety film as fast as funding allows. In a sense, the Library of Congress is to old films what monasteries were to written knowledge in the Dark Ages: Its scriptoria are the Dayton vaults, and the "new vellum" is safety film. While new research has shown that safety film is not a guarantee in itself of the long-term preservation of our film history, it is certainly less flammable. The Library of Congress is one of

the leading institutions that is testing optimum storage conditions for safety film. Only these safety copies are made available to researchers.

Not just Hollywood entertainment films are sought and retained; so are newsreels, old Fitzgerald travel talks, even educational and industrial films and those produced to further a social "cause." The lion's share are American, although there are notable collections of captured Italian, German and Japanese wartime films. There is also a remarkable archive of early American films rescued from an abandoned swimming pool in Dawson City in Canada, where they were used as landfill; though some were waterlogged, the Yukon Territory's bitter cold preserved these 35mm nitrate films.

Because the Library of Congress believes in preserving the "35mm experience"—with a large screen's worth of visual "information"—it does not make videotape copies of movies. Even the highest-definition television screens today can reproduce only about half of the three thousand lines of resolution on a 35mm frame of film.

Users of the Library of Congress motion picture collection are almost as varied as the films: sociologists, authors, lawyers, even a whole profession of specialists who search the reels for documentary filmmakers. They face one stern barrier: The films are accessible solely by title, not subject, so someone seeking a clip of, say, a romantic interlude along the Seine had best have a movie or movies in mind.

Of the Library of Congress's 250,000 film titles, 80,000 are television programs, although much of America's television legacy is lost forever. Even today, library managers

estimate, only one-tenth of 1 percent of television being produced in America is being saved in any organized way. ABC, NBC, CBS and the old Dumont network did not carry forward newspapers' tradition as media of record, in part because sponsors owned most of the early programs. Although an estimated 70 percent of network programs— including early "Today" and "Tonight" shows—do not survive, the Library of Congress does now receive the news broadcasts of NBC Television, gets several programs via copyright submission and holds more than twenty thousand kinescopes shot from 1948–1970. (Kinescopes date to the days of live television, when some programs were saved by pointing a movie camera at a television monitor.) These "kinnies" include such shows as the famous "lost" episodes of "The Honeymooners" that surfaced in the 1980s. Even adding in all the *local* television shows ever made and still being produced, less than 1 percent of America's television product produced from the 1939 "World of Tomorrow" New York World's Fair through today is thought to survive.

*Above: The conservation and restoration
teams at the Library restore not only
fragile rare books, but also playbills,
posters, manuscripts and prints.
(Photograph by Carol M. Highsmith)*

Chapter 4

To Preserve and Protect

We can enjoy a 1574 Bible, an 1846 daguerreotype or a 1901 cylinder recording because of the affectionate care or expert maintenance it received, or thanks to pure chance. But the predations of light, moisture, pollutants, rodents and insects, fire and abuse, chemical deterioration and simple old age have forever obliterated many treasures. Before others are lost, the Library of Congress, as a repository for the ages, mounts an aggressive conservation effort that stabilizes or repairs nearly half a million items each year.

"Restoration"—reviving the appearance of an artifact—is a small part of the Library's mission. It is not an art museum. While conservators will fill a tear here, a hole bored by a bookworm there, in order to keep the paper from being damaged further, they will not repaint faded illustrations or lost lettering. A case in point: An original copy of Pierre L'Enfant's plan for the new capital city in Washington was badly discolored by layers of glue, applied as a varnish shortly after the plan was completed. Carefully removing this coating could have perked up the Frenchman's work, but it would have destroyed Thomas Jefferson's now-faded, handwritten margin notations.

Instead, using infrared, ultraviolet light and computer digitization, the Library made a copy that actually enhanced Jefferson's jottings. The original was placed in a chamber of inert gas for preservation.

Other timeworn items see their "shelf lives" greatly extended. Before they are placed in the stacks, unbound print acquisitions and paperback volumes are sent out for binding, and millions of older books have been rebound. Part of the Library's staff is assigned to search out brittle books for immediate microfilming, and newspapers are routinely filmed. Preservation of *information* is paramount.

While some institutions have eagerly waded into mass deacidification to save crumbling nineteenth- and twentieth-century books, the Library of Congress has moved cautiously into diethyl zinc processing, testing books in small batches in an effort to overcome diethyl zinc's odor and iridescent-staining problems, which have flawed deacidification programs.

The treatment of a rare book—whose appearance and feel *are* worth saving—is far more labor-intensive. It is not unusual for a Library of Congress conservator to devote one hundred or more hours to revitalizing a single book. The work involves taking the volume apart; perhaps immersing it page by page in buffering and alkalizing solutions; carefully drying it under blotters and weights; and often resewing, repairing or bracing its rotting leather bindings. Old, cracked adhesives that held books together are replaced by simple substances like wheat-starch paste, which holds a book tight but can be easily removed by future conservators.

Veritable miracles have been performed: Once, remarkable records of the Russian Orthodox Church in

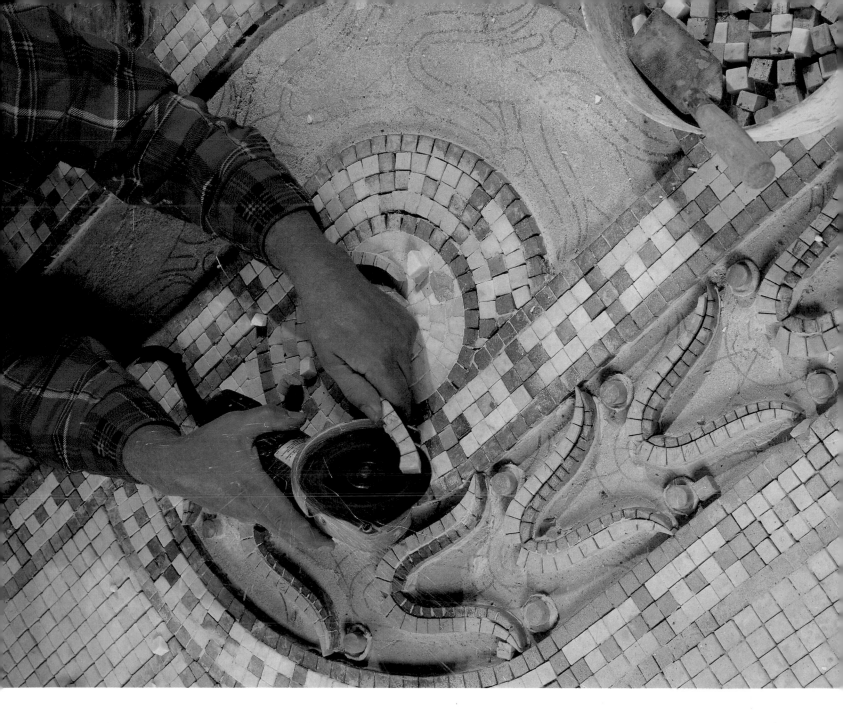

Alaska were turned into lumps of wet tissue by water that seeped through a seam in the Jefferson Building's copper roof; a conservator was able to tweeze the pages apart, dry and resize them, then rebind the volumes.

Not just the beauty, scarcity or fragility of an item plays a role in choosing whether it gets specialized care. Who wrote it? Who owned it? What edition is it? Was it secured by a famous binder? Is the typography or decoration unique?

Above: A Pagliaro Brothers stone craftsman restores the west center floor of the Great Hall's balcony, following a pattern sketched upon the floor by an artist. (Photograph by Carol M. Highsmith)

41

One memorable project involved six printings by English printer William Caxton of a Rosenwald Collection rare book, *The Mirror of the World*. In examining them, a scholar noted that vellum strips used to reinforce the volumes came from a previously unknown printed indulgence by Caxton. Library conservators carefully removed the strips, reassembled them into separate volumes and made them available for scholarly examination. Another time, the staff built a giant trough just to bathe an early, five-by-eight-foot architectural drawing of the Library of Congress itself.

Conservation Office staffers—most of whom are not chemists but true artists with a knowledge of chemistry—subscribe to the bromide, "They don't make 'em like they used to." Indeed, fifteenth-century rag-paper editions have held up better than today's mass-produced wood-pulp volumes or nineteenth-century books printed on highly acidic paper.

The Library of Congress—which administers the National Film Preservation Board—is the country's only archive with a publicly funded nitrate film preservation laboratory. It's located in cinderblock vaults on the grounds of Wright-Patterson Air Force Base in Dayton, Ohio, once the site of the Air Force training film operation. Cold storage, coupled (as fast as funds will allow) with the transfer to safety film, is the most expedient preservation technique for old nitrate movie stock and photographic negatives. Of course the longevity of any film is affected by how it was treated *before* the Library acquired it. Cold storage can only slow, not stop or reverse, deterioration of the molecules in a film's emulsion. There are some early films, in storage but

not yet copied, that the public has not seen since their original run, and the vivid hues of many later color films, including Academy Award–winning movies of the 1950s and 1960s, are fading faster than conservators can copy them.

The Library copies old audio tapes, too, before they curl or stick together, or their magnetically charged iron-oxide particles flake off and fall away like dust. Today's thin audio- and videocassette tapes are even less stable; they deteriorate quickly. Technicians in the Motion Picture, Broadcasting and Recorded Sound Division make equalized, enhanced copies of some early recordings for Library of Congress sets sold to the public, but they do not enhance archive copies. For every noise or crackle that is removed in the making of an electronically embellished copy, other frequencies are lost, changing the original sound forever. Computerized digitization is no panacea; its considerable costs aside, a digital copy—no matter how much information it crunches into a space-saving format—ends up on some kind of magnetic medium. Conservators twenty-five or thirty years from now will have to remember to "refresh" or re-record these digital archives before they, too, begin an inexorable disintegration.

Critical to preserving the Library of Congress collections, of course, is security. Thievery, arson and malicious damage to a collection are any library's bête noir, and the Library of Congress was never immune. Not just students on a term-paper deadline and mendacious researchers are involved in the pilfering; senior-level government officials, highly credentialed scholars and even an occasional Library employee have also been caught ripping out pages or

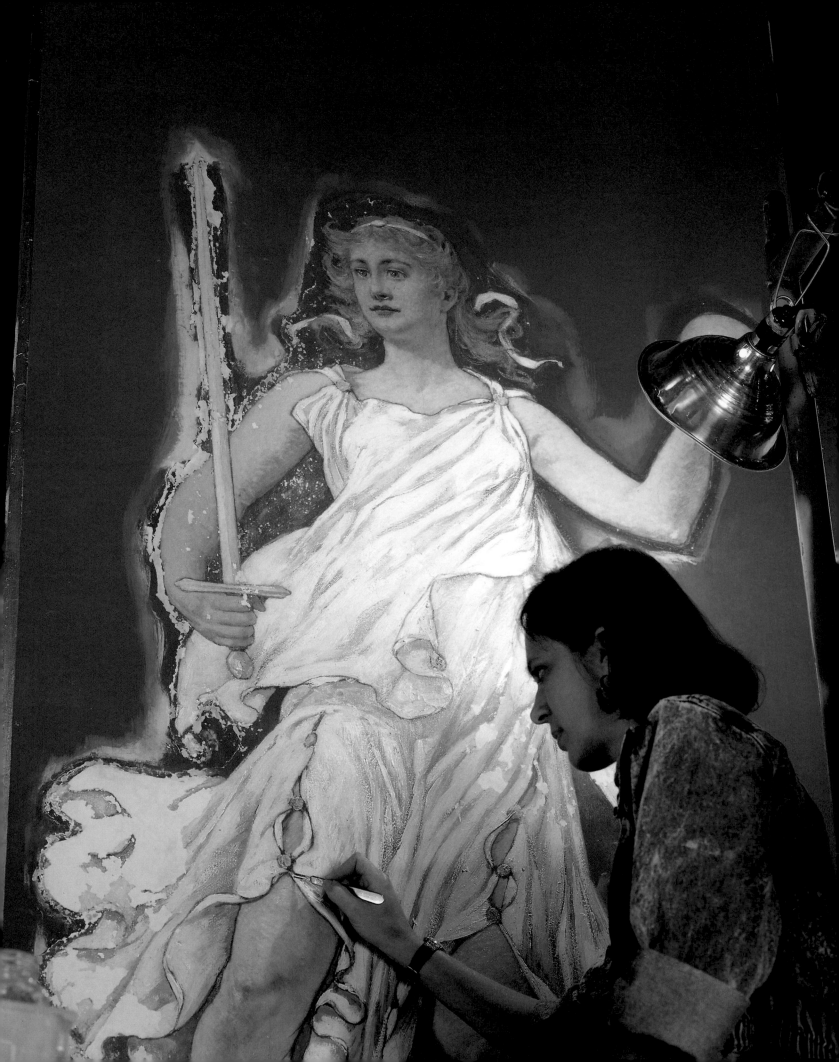

stealing books to sell. Lamentable losses had always been considered a price of egalitarian openness at America's greatest library. So were occasional inconveniences, such as the two-week closing of an entire division one Christmastide in the early 1990s so its holdings could be put in cold storage to kill an infestation of lice brought in by "street people" who sought relief from the cold.

But the balance tipped to greater security in 1992, after an inventory started in 1978 revealed about three hundred thousand missing volumes. Librarian James H. Billington—himself a Russian scholar and inveterate browser—made the unpopular decision to close the stacks, even to serious scholars. Most staff members, who often used the collections for pleasure reading and outside research projects in off-hours, also lost their stack passes outside their divisions. Other security measures, including the tagging of hundreds of thousands of books with a "target" that triggers an alarm when passed through detection gates, were also instituted. Billington said he had little choice, that while most books defined as "rare" were reasonably well guarded, thousands of equally irreplaceable, one-of-a-kind nineteenth- and early twentieth-century books were "walking."

Many critics inside and outside the Library assailed the measures as "draconian" and corrosive to morale, arguing that only by perusing an entire assortment of books is groundbreaking research possible. Billington countered that misfiled or stolen books cannot be browsed, and that in an electronic world, if the original storehouse is destroyed or vandalized, there is nothing to digitize. Editor Lynne Shaner agreed. She wrote the *Washington Post*,

Left: Gayle Clements, a conservator with the Perry Houston Associates restoration team, mends Justice, *one of George Willoughby Maynard's eight figures representing the Virtues near the East Corridor of the Great Hall of the Jefferson Building. (Photograph by Carol M. Highsmith)*

"Anyone who saw what I saw—an entire botany section mutilated just so it's suitable for framing—would find it difficult not to lean in that direction."

Rued one division chief, "We'd been vulnerable too long."

Vigilance has also increased against an even bigger nightmare: fire. The specter of disastrous blazes at the Los Angeles Central Public Library in 1986 and the Library of the Academy of Sciences in Leningrad in 1988, and a raging fire in the nitrate-film stock of the National Archives at a warehouse in Maryland, were enough to convince the Librarian of Congress that he did not want combustible nitrate films—long stacked in the Jefferson Building basement—stored any longer beneath the modern world's greatest intellectual storehouse. They were removed to Dayton, Ohio. Burning nitrate creates its own oxygen; it will burn even under water or sand, making it almost impossible to extinguish.

Librarians had only slowly come to appreciate modern fire protection. Many vehemently resisted the installation of sprinkler systems, fearing not so much a soaking following a fire, but overnight pipe ruptures that would saturate their collections. Library of Congress buildings had no sprinklers well into the 1970s, and the new James Madison Memorial Building was originally designed without them. But safety experts convinced the Librarian that the Madison Building, with its total of 2.25 acres of tightly compacted movable shelves on each level below ground—and 3.5 acres of floor space on each level above—was akin to a high-rise building lying on its side. Sprinklers were added to the blueprints and also installed in the Jefferson

and Adams buildings, whose stacks had been potential flues for decades. With both sprinkler and smoke-detector systems, a strict prohibition on smoking in all but a few lounge areas and updated emergency evacuation plans, all three buildings—and the Library's warehouses—are now better geared for trouble.

Above: The Holocaust archive in the Hebraic section of the Africa and Middle Eastern Reading Room holds numerous volumes that serve as memorials to Jewish communities destroyed by the Nazis in World War II. These books provide detailed information, photographs and records of these communities. (Photograph by Carol M. Highsmith)

CHAPTER 5

Specialty Corners

Just as a persistent prospector will dig past the first veins of gold in search of the mother lode, so Congress and scholars will often work quickly through the Library of Congress's general collection and pursue specialized research in the Library's law, science and technology or regional reading rooms.

The Law Library of Congress—the largest law library in the world and the Library's oldest separate department (1832)—has amassed the most complete collection of current American legal materials anywhere, as well as vast sets of Roman, English and early American lawbooks and one of the most comprehensive storehouses of foreign official gazettes. Its more than two million law books—not counting its own twenty-five thousand rare legal volumes in a separate reading room—are housed in movable stacks beneath the Madison Building. The Law Library publishes the U.S. Constitution and other seminal American documents in several languages, studies campaign financing of foreign national elections, researches everything from drunk-driving laws to firearms regulations abroad and has prepared a thesaurus of civil- and common-law terms

designed to assist emerging democracies. As the federal government's only foreign law research service, the Law Library is heavily used by foreign affairs committees of Congress, the Immigration and Naturalization Service (on issues like asylum, adoption and citizenship requirements), embassies and a bevy of graduate students in international affairs. The Law Library turns to Library of Congress field offices abroad, as well as other nations' parliaments and the research services of international agencies like the European Union, to search out current statutes and works in progress. It is not uncommon to find members of Congress rubbing elbows with law students and messengers from law firms in the Law Library reading room; Senator Paul Simon of Illinois, for instance, wrote a book on his portable typewriter there.

Because the Library of Congress, in a world of instant electronic information-sharing, can no longer afford to rely on international mail alone to stay current, the Law Library's Hispanic section has embarked upon a project that could soon quickly spread the lifeblood of international law: authenticated copies of laws and abstracts. It's called the Global Legal Information Network, which began with successful tests in Brazil and Mexico. The idea is to instantly transmit documents into an international database, and to standardize abstracts so that countries of the world can quickly compare notes on legislation, import-export requirements, immigration, labor law, shipping and insurance. Such information is crucial to international investment and the growth of regional partnerships. To truly go worldwide, however, the Global Legal Information Network will need large-scale private support.

Inquiries about other parts of the world can also be answered in the Library's four regional reading rooms. The purview of the Africa and Middle East Room, for instance, extends from the new Central Asian republics of the former Soviet Union to sub-Saharan Africa. Because regular publishing outlets are scarce in these regions, the division relies on the Library's field offices to obtain the latest pamphlets, government documents, political materials, and newspapers. The division's Hebraic section has amassed more than 140,000 books in Hebrew, Yiddish and related languages like Judeo-Spanish. Included in its strong Holocaust archives is a large

Below: Librarian of Congress Archibald MacLeish commissioned noted Brazilian muralist Candido Portinari to paint Entry Into the Forest *in 1941. Along with Portinari's three other murals in the Hispanic Society Reading Room in the Jefferson Building, this tempura mural is a true treasure of the Library. (Photograph by Carol M. Highsmith)*

collection of "memorial volumes" from European Jewish communities destroyed in World War II. The sub-Saharan Africa section features the records of the American Colonization Society and letters to and from Liberian settlers.

In addition to serving as a clearinghouse for the world's most complete collection of materials on Latin America, the Caribbean and the Iberian Peninsula, the Library's Hispanic Division actively collects the newspapers and small-press prose and poetry of what was once called America's "Spanish borderlands," from Florida to Northern California. *A Handbook of Latin American Studies* and the *Archive of Hispanic Literature on Tape* are two division highlights. The latter features more than 550 authors—six of whom are Nobel Prize winners—reading their own works. The division's reference librarians also guide researchers through the estimated two million books in the Library's general collection, as well as myriad materials in the special collections, that deal with the Spanish and Portuguese world—in both the geographic and cultural senses.

The European Division provides access and guidance to an abundance of European materials throughout the Library, with Western and Eastern Europe equally well represented. After Americana, items from England and Ireland make up the Library's second-richest geographic strength. German collections are also particularly strong (approximately 2.25 million volumes), followed by French material. Even some of the small European collections, such as the Dutch and Flemish volumes and maps, are surprisingly broad.

The division's Eastern European section evolved from Slavic roots, with emphasis on reference assistance pertain-

ing to Russia, the Slavic nations of Eastern and Central Europe and the Baltic countries. The seven hundred thousand Russian-language volumes are equaled by the number in other languages of the former Soviet Union and in Western languages about Russia. This regional collection includes so-called *libri prohibiti*—books and periodicals that were not available to researchers in Central and Eastern Europe under Communist regimes.

The Library of Congress had a long-lived and successful relationship with the state libraries of the USSR. Now that the old Communist centralized distribution system has collapsed with the Soviet empire, exchange relationships have been established with the libraries of successor states. By subscription and from an agent in Moscow, the Library receives about 250 vernacular-language newspapers and periodicals.

The Asian Division collection—largest outside that continent—includes more than seven hundred thousand materials in Chinese (including a sixty-thousand-volume rare book anthology dating to the tenth century), eight hundred thousand in Japanese, one hundred thousand from Korea and more than two hundred thousand from other nations of Southeast Asia. Division staff report a flood of new books from the

Above: These young boys represent Asia (in flowing "silk" robes) and Europe (with lyre and book). Located near the Grand Staircase on the north side of the Great Hall, these figures by Philip Martiny correspond to continents visible on the portion of the globe held between them. (Photograph by Carol M. Highsmith)

Right: This detail from Science, *a painting by Kenyon Cox in the Great Hall, shows a cherub holding a globe upon which the signs of the zodiac appear. (Photograph by Carol M. Highsmith)*

People's Republic of China, but their rising cost limits acquisitions to five thousand to seven thousand a year. Among the most useful holdings are more than four thousand local Chinese gazetteers, the equivalent of U.S. county histories, chronicling centuries of customs and traditions.

What some call the "forgotten special collection" is a gathering of more than four million technical reports in the Science and Technology Division. These ephemeral writings are even more revealing than scientific journals because they detail *failed* as well as successful research. While most working scientists can tap into their own specialized libraries, it is scientific literary researchers, patent searchers and information brokers on the payroll of large

science institutions who frequent Library of Congress Science and Technology collections. Division librarians—most of whom hold advanced scientific degrees—are skilled at "surfing" worldwide computer networks. The division takes pains to retain staffers fluent in Japanese, so that important technical developments in Japan do not go unnoticed. This is important for a nation that does not have a single national science library but must rely instead on the fragmented efforts of the Library of Congress, the National Library of Medicine, the Commerce Department's National Technical Information Service and the collections of large universities and labs.

Left: Raymond Loewy, one of the inventors of modern industrial design and a principal designer for the Studebaker Corporation, produced this design sketch for the Avanti automobile in 1961. (Courtesy of the Library of Congress)

CHAPTER 6

America's Roots

All of the Library of Congress is a historian's fairyland, but two of its collections—Local History and Genealogy, and the American Folklife Center—uniquely evoke Americans' passion for their past.

Every day, both scholars and average citizens search the Library's expansive genealogical records, many after having first pored over official government documents like census records down the hill at the National Archives. Mustering and regimental records from the Civil War, for instance, are the Archives' province, but one would turn to the Library of Congress to track where the regiment fought day by day. The Library also collects British pedigrees and registers back to the thirteenth century, plus many early day-to-day American birth, marriage, death and probate records once kept at the state level. It also has bound (and still collects) more than fifty thousand family histories, some elaborately researched, others typed on a few pages.

A congressional resolution at the time of the 1876 U.S. centennial asked American communities of every size to write their own histories and deposit them at the Library of Congress. Thousands did, and these—as well as later

Left: Frances Densmore, who conducted many field trips for the Smithsonian Institution's Bureau of American Ethnology, sits with Mountain Chief of the Blackfoot tribe listening to wax-cylinder recordings in 1906. The Edison cylinder recording machine was invented in 1878 and first used for field recordings in 1890. Nearly three thousand of Densmore's recordings are now part of the collections of the American Folklife Center. (Courtesy of the Library of Congress)

"mug books" sold to towns by traveling publishers' agents—form the nucleus of the Library's more than four hundred thousand volumes on local history. Its topographic studies, guidebooks, histories of ethnic and religious groups—even telephone books and city directories—are useful, too. While a local library in, say, Cuyahoga County, Ohio, would likely have the most detailed materials on the history of Cleveland and its environs, the Library of Congress is useful in tracing the movements of families and groups to the shores of Lake Erie from other parts of the country and abroad.

Elsewhere in the Library, the American Folklife Center has brought together many research, archival and preservation efforts. The Library's collection of American folksongs got its start in 1928 when a feisty visionary, Robert Winslow Gordon, whose work was underwritten by wealthy Philadelphians, took wax cylinder recording equipment and set up what he called a "field station" in Darien, Georgia, to record the songs, chants and thoughts of Gullah-speaking African Americans from the Georgia Sea Islands and Appalachian ballad singers. The pretext with which Gordon won his patrons' support was that no nation could have its own great *classical* music without exploring and incorporating native themes. So absorbed in his work was Gordon that Librarian of Congress Herbert Putnam was reduced to writing the anthropologist's wife, demanding to know where her husband might be found.

Not long after Gordon lost his sponsors—and his job—John Lomax, a Texas banker with an enduring interest in folk culture, took his place. From the Depression's Dust Bowl days through the early 1940s, he and his son, Alan, collected more than twenty-five thousand additional

samples of folk music and art, and brought "folklife" to prominence through White House concerts, contacts with motion picture producers and their own publications. National interest in folk culture grew in the 1960s and 1970s, and the bicentennial provided the occasion for Congress to recognize folk culture's importance by creating an American Folklife Center at the Library of Congress. The original collection of American folksongs has grown to include a whole range of material and is now called the Archive of Folk Culture.

While its more than six hundred thousand manuscripts, forty thousand hours of sound recordings, 250,000

Below: The Folklife Center documented rancher Leslie Stewart on a cattle drive in October 1979 as part of the Paradise Valley, Nevada, Folklife Project. (Photograph by Carl Fleischauer, courtesy of the Library of Congress)

Above: Interviewed as part of the Blue Ridge Parkway Folklife Project (Dobson, North Carolina) in 1978, Alma Hemmings (left) shows Folklife Center researcher Geraldine Johnson a crazy quilt she made in 1937. (Photograph by Lyntha Scott Eiler, courtesy of the Library of Congress)

photographs and a quarter of a million ephemeral items contain some oral histories (notably sixty-seven hours of reminiscences of former slaves), Center field projects seek to document a whole range of cultural expressions within the nation's many regional, occupational and ethnic groups. Performances by Native Americans, country and bluegrass groups like Bill Monroe and his Blue Grass Boys and legendary folk musicians like Huddie "Leadbelly" Ledbetter have been turned into Library of Congress Folklore Recordings, available for purchase. Through the Folklife Center's Federal Cylinder Project, turn-of-the-century recordings of hundreds of Indian people on wax cylinder have been transferred to magnetic tape and delivered back to their

communities, where many young people are hearing music of their ancestors that was thought to be lost.

The Center treats its ethnographic materials as created collections that belong together: photographs of a country woman in her kitchen, a phonographic sound recording of her family singing in the parlor, an interview on how a quilt was made by the woman and her friends and field notes detailing the researcher's visit. Active outreach, such as a several-year study of Italian-American wine growers, tuna fishers, garlic growers, steelworkers and even cowboys in the West, continues and supplements materials received from remote locations like the rain forests of New Guinea and Belize.

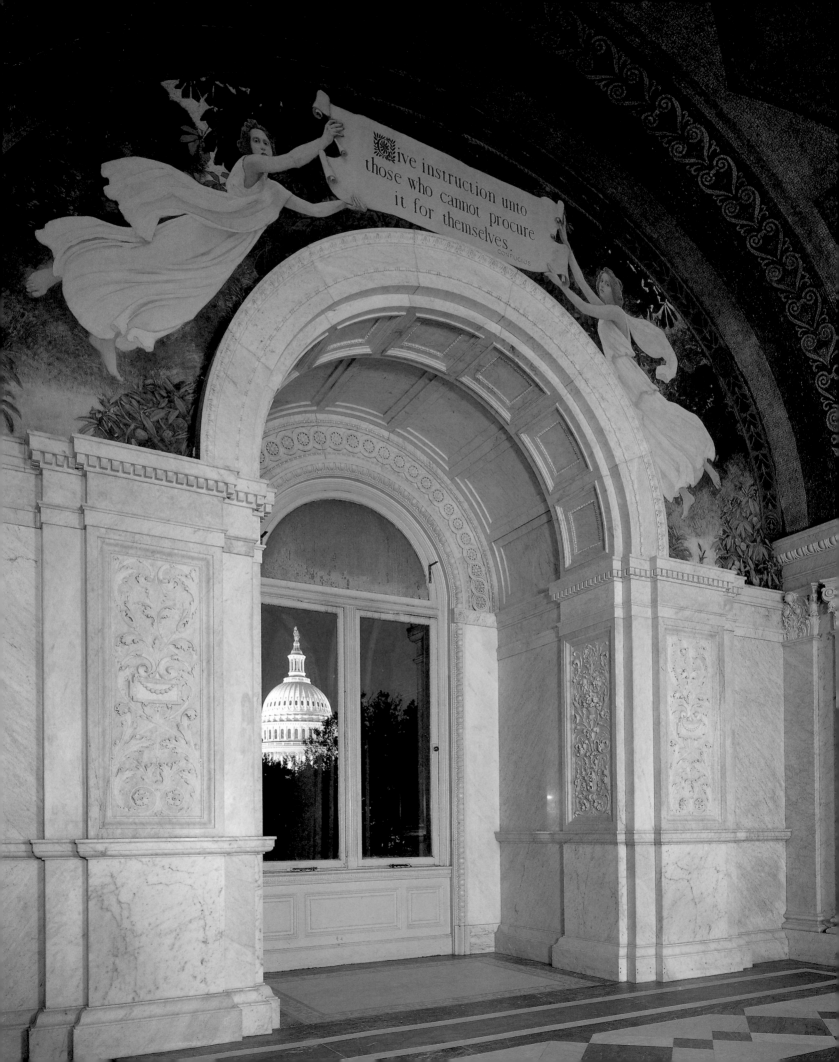

CHAPTER 7

Things to Which a Member May Refer

At first Congress had no need of a research service within the Library. As a part of the legislative branch of the young American government, the whole Library of Congress served that function. But after the Library became the United States' copyright depository in 1870, and scientific and scholarly activity mushroomed with the growth of graduate schools, researchers the world over came knocking and were accommodated. Finally in 1913, Librarian of Congress Herbert Putnam got approval to carve out a legislative reference service, not just to answer, but also to *anticipate,* questions from its parent body.

Now called the Congressional Research Service, that division today responds to more than six hundred thousand telephoned, faxed, computer-generated and in-person inquiries each year from members, their staffs and congressional committees. However simple the request ("Who's the ambassador from Zimbabwe?"), how complex ("What are the public-policy implications of a decline in world oil production?") or even how unexpected ("Please send over some jokes for a lunch with Alaskan fishermen."), it's the job of the Congressional Research Service to meet the

Left: The Capitol Dome may be glimpsed through windows along the North Corridor of the Jefferson Building. The painting above the window is one of the many in the building by Charles Sprague Pearce. (Photograph by Carol M. Highsmith)

request. Though it has full access to its own broad array of contracted specialized databases, the SCORPIO database and extensive reference materials, as well as Library of Congress holdings, CRS is not expected to know the answer to every question. It is, however, expected to track it down, anywhere in the world.

Some questions can be answered in a flash by CRS's seven research divisions or cadre of senior specialists, who have the credentials of a fine university's faculty in fields as diverse as constitutional law and nutrition. They do not send information until asked, but they try to anticipate world hot spots and contentious national issues in preparing their reports, issue briefs and analytical models.

The Congressional Research Service works for members of all political parties and without judgment about the partisan advantages to which the information might be put. What may seem frivolous ("How many pull-top beer and soda cans were sold last year?") may contribute to serious legislation on, say, increasing soft-drink exports or the danger of pull-tabs to wildlife. The relationship of member and committee offices to the CRS—the requests, telephone exchanges, in-person briefings, memos—is treated in lawyer-client confidentiality by the Service. Members of Congress often release work done for them to Congress as a whole or to the press, but this is not the anonymous work of faceless bureaucrats; CRS analysts sign their work as a matter of professional pride and accountability. Their work is authoritative but not infallible; CRS managers chuckle about the time the staff rushed to meet a member's request for background on euthanasia, only to learn that he had really wanted to know more about young people in China and Japan: "youth in Asia."

Each month, the Congressional Research Service's updated guide to its "products" lists the esoteric (*Disparate Impacts of Federal and State Highway Taxes on Alternative Motor Fuels*), the controversial (*Homosexuality: Selected Studies and Review of Possible Origins*) and the refreshingly direct (*Ramps*).

The Congressional Research Service will *not* write legislation or do research about one member of Congress for another, won't give personal medical or legal advice and won't do constituent casework ("What happened to my Social Security check?"). Members use CRS as a reality check—"Is what I'm hearing true?" "What are other viewpoints?"—and to see if problems back home are isolated or part of a national trend. As an arm of Congress, CRS will not do original research for executive or judicial agencies—even the president or chief justice. But it will share reports already produced—without divulging which member asked for it—just as it makes use of material such as Commerce Department census data and printed Supreme Court decisions.

Congressional staffers typically want CRS to respond "yesterday." Any request that will clearly take more than forty hours of a researcher's time—especially when the work will require dollars spent to contract outside experts —must be solicited in writing by a member of Congress.

Each year the Congressional Research Service generates more than two million photocopies of articles, reports and abstracts. In 1993, it produced and delivered twenty-one hundred copies of original video and audio briefs on cassette for busy senators, representatives and staff, some of whom spend many hours a week in cars and planes.

Right: A restoration team's scaffolding placed around the statue of Freedom *on top of the Capitol Dome provided the photographer's foothold for this photograph of the Jefferson Building (right) and Supreme Court (left). (Photograph by Carol M. Highsmith)*

Twenty years ago, CRS offices were a maelstrom of clanking typewriters, ringing phones and a never-ending human din: "I've got a rush." "Two is on hold." "Get me the speaker's office." "Who is doing the Geneva Peace Conference this month?" The workload is even more maddening

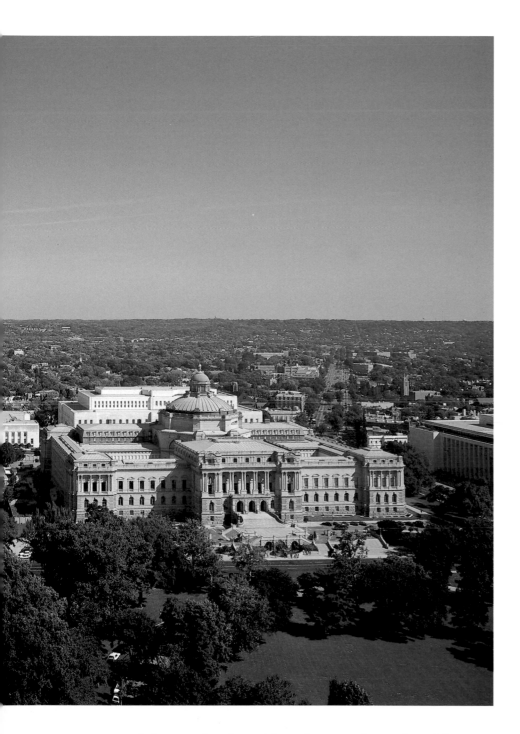

now, and the perils of working close to the political fire are undiminished, but with the great databases, with SCORPIO and terminals tied to the vast Library of Congress collection, offices are quiet, the pace is usually more civilized and the work of the "faculty" less like a newsroom.

Above: This pamphlet cover was designed by Samuel Langhorne Clemens, or Mark Twain, for his collection of sketches. Clemens sent the cover with a letter in his own hand to the Copyright Office, asking for a copyright on both the design and the contents. (Photograph by Carol M. Highsmith)

CHAPTER 8

Copyright and Kitsch

Beginning in 1783 in Connecticut, when lexicographer Noah Webster helped get "an Act for the Encouragement of Literature and Genius" passed, twelve of the thirteen states that had been original American colonies issued copyrights. Seven years later, Congress enacted the first federal copyright law, giving federal district courts the authority to issue copyrights on maps, charts and books (listed in that order, as maps of the vast frontier were especially prized). After the courts recorded the copyrights, actual copies of the works were then supposed to be forwarded to the U.S. secretary of state.

Neither the district courts nor the secretary had much use for many of the books and maps they received. But the potential of copyright as a free and easy way to build a collection was not lost on others, especially after 1837, when the British Museum's library became the empire's "Keeper of Printed Books" and almost immediately leapt into the top echelon of world libraries.

When the U.S. Congress established the Smithsonian Institution in 1846, the authorizing act included a request that—in addition to the usual copy dispatched to the

nearest district court—authors send a second copy of their work to the Smithsonian and a third to the Library of Congress. Since the courts still registered the copyrights, relatively few writers or mapmakers bothered to send the extra two copies. Still, the Smithsonian's sprightly librarian, Charles Coffin Jewett, recognized the value of this stream of new literature to his budding scientific institute. He beseeched Congress to designate a true national library—not surprisingly, his own. Problem was, Jewett's boss, Smithsonian Director Joseph Henry, a pure scientist, had little use for the mishmash of poetry, fiction and pure frivolity that came in with the maps and scientific tracts. When articles critical of him, planted by Jewett, began popping up in the press, Henry put an end to Smithsonian National Library schemes by firing his librarian.

Aloof from the fray, over at the Library of Congress, which was busy buying almost twenty times more books than arrived via copyright, Librarian John Silva Meehan was equally lukewarm about over-the-transom literature. In 1859, he persuaded Congress to eliminate the Library of Congress deposit altogether.

Copyright was the last thing on people's minds during the Civil War that soon followed, but in 1865 new Librarian of Congress Ainsworth Rand Spofford showed up, imbued with copyright fever. He wanted every free volume he could get, and Henry, down the Mall, was only too happy to get him started by crating up and shipping over most of nineteen years' worth of Smithsonian copyright deposits. Quickly Congress bent to Spofford's entreaties to centralize copyright registration under the Library of Congress, and the exuberant Librarian hauled old copyright holdings from the secretary of state's office as well.

By *requiring* authors, mapmakers and songwriters to submit two copies, a new Copyright Act of 1870 helped the once-meager congressional library to quickly multiply its holdings. That this windfall soon overflowed the Capitol Building stacks hardly fazed Spofford. When books began to spill out of the aisles and into hallways, Spofford had the ammunition for his drive to get his own Library of Congress building.

Below: The Copyright Office collects everything from recently published music and scholarly works to the kitschiest items of pop culture. This display bears the Muppets Bert and Ernie (top), the first Barbie and Ken dolls (second tier, right), the Pink Panther and the original Maltese Falcon (bottom, left of center). (Photograph by Carol M. Highsmith)

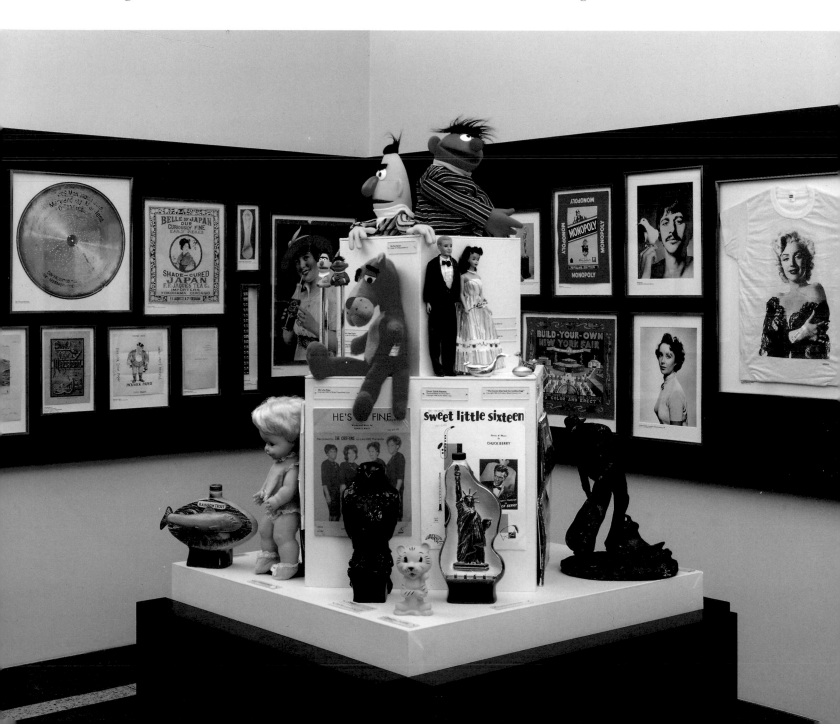

Today the Library of Congress is wrestling with the volatile question of how to protect authors' intellectual property rights should substantial parts of the Library's collection accelerate out of Washington in digital form on the electronic superhighway. This is no problem for works in the public domain, or for most older copyrightable works that are no longer commercially viable, and many digitized works are copyrighted. But this would not deter unauthorized use of materials so widely dispersed in the electronic domain. Congress and several advisory groups from the Library and the computer and publishing worlds have wrestled to find a way to give the public instant access to digitized works, while fairly compensating the copyright-holder.

The variety of materials submitted along with the more than six hundred thousand annual claims of copyright is astounding. Computer programs and games, books and photos in digital format and even semiconductor chips are sent to the Library of Congress for copyright registration.

As always through its history, many of the materials submitted for copyright deposit are literary treasures—or will be recognized as such with the passage of time. But the Library also receives bemusing and "passing fad" items, including "collectibles"—three-dimensional objects sent in for copyright before 1978, when Congress changed the law and instead allowed applicants to submit photographs or descriptions of these unconventional objects. A delightful creative goulash of piggy banks, porcelain princesses, rhinestone jewelry, Styrofoam snowmen, whiskey decanters, assorted mascots, board games and other Americana kitsch are kept at the Library's Landover, Maryland, ware-

house. Though these trinkets occupy the opposite end of a taste scale from a Gutenberg Bible, they are fondly preserved as icons of the nation's pop culture. Some of the most endearing, such as authentic Kewpie dolls, the original Barbie doll and the first Bert and Ernie figures from television's "Sesame Street," are occasionally exhibited at the Library's public buildings.

Stored at Landover, too, are incredible assortments of posters, bumper stickers, science-class wall charts, cereal boxes and other "advertising art"—even giant billboard sheets—plus uncounted thousands of cassette recordings of amateur musicians warbling their new works. Even after the required retention period, the Library holds onto some objects for use in exhibits and as instructive examples of the trends in American popular culture.

COPYRIGHT BASICS

- Without filing any kind of application, an author has a valid copyright on his or her original created work the moment it is "fixed"—committed to paper, recording or other lasting medium. The copyright owner may put the word "copyright" or the familiar ©, followed by the copyright owner's name and the year of first publication, on the work.

 So why bother registering it at the Copyright Office of the Library of Congress? Having a certificate is essential to enforce your copyright in court. The copyright-holder also has the right to dramatize, rearrange, abridge, adapt or translate his or her creation into a "derivative form," as when a novel is made into a movie.

- Don't confuse copyright with the patent or trademark processes, which are Department of Commerce functions. "Original works of authorship"—the fruits of the creative, artistic process—are protected by copyright. Inventions—mechanical gizmos, chemical processes, even new kinds of plants—get patents.

- While a copyright owner has exclusive copyright rights in his or her work, others may have a limited right of "fair use" of short excerpts. The law is fuzzy, though, as to what constitutes fair use of works such as movies and recorded sound. Contrary to popular belief, there is *no* flat right to excerpt fifty words or fewer from a text. Lifting a single sentence from a short poem might infringe on a copyright.

- The duration of a copyright has changed over the years. A new work today is copyrighted from the moment it is fixed in tangible form until the author's death—*plus* another fifty years. If a work is anonymous, or written for hire or under a pen name (and you don't reveal the real author to the Library of Congress), the term is one hundred years from its creation, or seventy-five years from the date it was published, whichever is shorter.

- Minors—even infants—may own a copyright.

- Ideas may not be copyrighted. Neither may works that have not been fixed, such as a dance or impromptu speech that has not been recorded. Titles may not be copyrighted; however, they may well be covered by trademark protection.

- The top U.S. copyright officer is the Register (not registrar) of Copyrights, usually a lawyer, reporting directly to the Librarian of Congress.

- Two copies of published works (but just one of unpublished creations) must be submitted with a copyright application. However, the regulation allows creators of three-dimensional works to send photographs or descriptions of their T-shirts, birdbaths or other masterpieces.

- Other rules and nuances of copyright, information on costs and procedures and many other topics are covered in the free circular, *Copyright Basics*, from the U.S. Copyright Office. For a copy, write to the Copyright Office, LM-455, Library of Congress, Washington, D.C. 20559-6000.

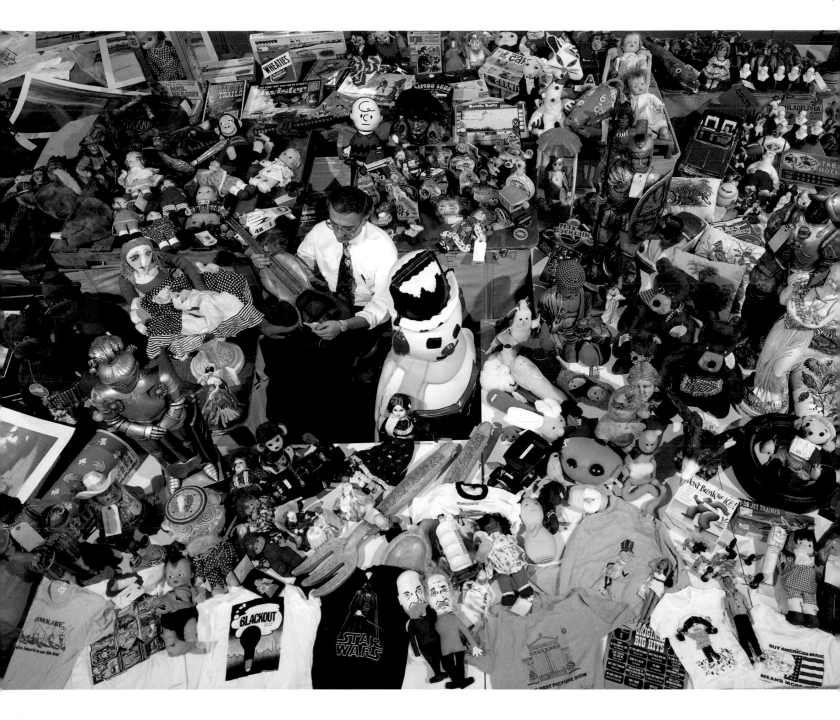

Above: Three-dimensional copyright deposits surround Frank Evina, Senior Copyright Specialist. Before a 1978 revision in the Copyright Division's rules, samples of all three-dimensional creations had to be sent to the Library for filing. The problem of inadequate storage space inspired the revision, which now requires only a photograph to accompany copyright requests. (Photograph by Carol M. Highsmith)

Above: The Vatican Library exhibit, displayed in the Southwest Gallery of the Jefferson Building in early 1993, contained some treasures that have never before left Rome. (Photograph by Carol M. Highsmith)

CHAPTER 9

Reaching Out and Reeling In

Not just copyright deposit pumps what Librarian Ainsworth Rand Spofford once called the "oceans of books and rivers of information" that cascade into the Library of Congress. So does the Library's annual purchase of approximately one million items, in addition to gifts—sometimes of entire collections—and exchanges.

Often collectors will agree to donate not just books but also maps, manuscripts, musical scores or other memorabilia (like George Gershwin's piano and Ira Gershwin's writing desk)—for which they or their heirs receive a tax deduction. Or they may strike a partial gift/partial purchase agreement. Sometimes gifts are combined, as when an elderly anarchist was persuaded to add his pamphlets and snapshots to the array of 10,250 items that collector Paul Avrich was preparing to donate to the Library of Congress. "The *government* library?" the old anarchist wondered suspiciously. "No," replied Avrich. "The *people's* library!"

When it comes to the gift of collections, the Library prefers an all-or-none arrangement; it likes to see them kept intact, even if it means another library wins the prize. If some of a donor's rare books duplicate those already in the Library's

holdings, it will keep the better copy and seek the donor's permission to exchange or sell the lesser-quality duplicate.

More than 60 percent of the items that the Library buys come from abroad. They range from rare books to reference volumes. The Library has standing purchase arrangements with dealers in cities like Paris, Hong Kong and Moscow. They work on "approval plans": given parameters of the kinds of holdings the Library is seeking, such as every new book on regional history, the dealers ship books to the Library and take back, for credit, those not accepted.

The Library also has more than eighteen thousand exchange agreements with other world libraries, academic associations and foreign governments. For example, it trades official U.S. Government documents for copies of other nations' laws and official publications. World events can present sudden challenges, as when the breakup of the Soviet Union sent Library of Congress officials scurrying to sign more than a dozen new exchange agreements with former Soviet republics.

The Library tries to be broad-minded in determining what works to acquire. Something of limited scholarly interest today may be prime research material tomorrow; who would have thought years ago, for instance, that the whole run of the "I Love Lucy" television program would be prized? Voluminous collections like the often-droning proceedings from the floor of the U.S. Senate and House of Representatives present a storage and preservation challenge, and one might wonder about their long-term value. Yet how delighted would we be today to be able to see and hear Daniel Webster or John C. Calhoun in the well.

The Library of Congress is the principal repository for

Right: Seen only by the Library's most esteemed researchers, the Members' Room bears elaborate ornamentation such as Frederick Dielman's mosaic depicting History with Mythology and Tradition over the marble fireplace. (Photograph by Carol M. Highsmith)

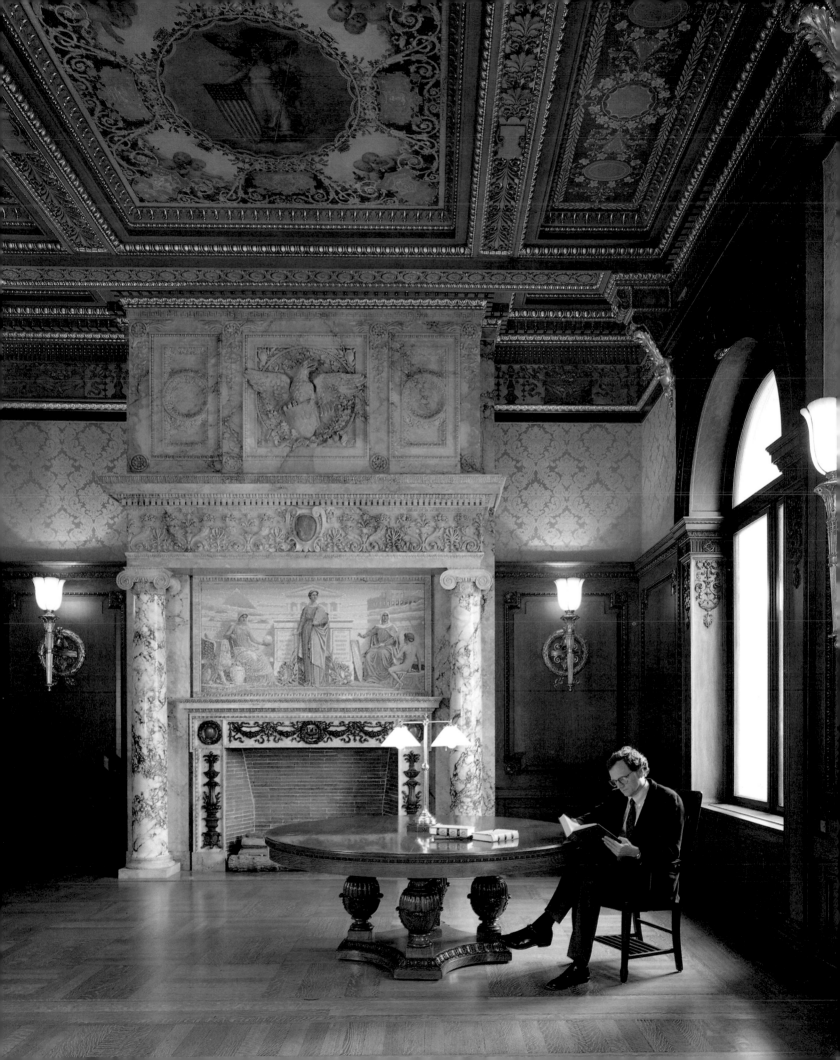

On Display and In Performance

Some of the most captivating portions of the Library of Congress collections are revealed in special exhibits—sort of the Library's "department store windows." They showcase books, photographs, maps, manuscripts and artifacts like the contents of Abraham Lincoln's pockets the night he was shot at Ford's Theater. Some displays, such as the 1988 "Documenting America" collection of haunting Farm Security Administration photographs from the Great Depression, travel to libraries and galleries nationwide after they close in Washington.

Exhibits fall into four themes:

- "Great Libraries and Written Traditions." These include *Rome Reborn: The Vatican Library and Renaissance Culture* (1993).
- "Treasures of the Library of Congress," including *From the Ends of the Earth: Judaic Treasures of the Library of Congress* (1991) and the opening of a special gallery of about 150 rotating treasures in the newly renovated Jefferson Building in 1995.
- "Exploring the American Character and Past," traversing American myth, history and traditions. Examples are *The American Cowboy* (1983) and *The American Journalist* (1990).
- "Reviewing the Past Century," with plans for a Sigmund Freud exhibit in the spring of 1996.

The Library's exhibits, which often include audio "headset tours" by prominent scholars, give visitors an idea of how specialists can look at the same set of evidence and arrive at different conclusions. Not all displays are sweeping in scope; the 1990 exhibit *My Dear Wife*, for instance, provided an intimate social and political history of the nation, captured in the letters of congressmen back home to their wives (and Rep. Clare Booth Luce to her husband in Connecticut). Divisions such as the Hispanic Cultural Society and the American Folklife Center also offer public performances and exhibits.

Exhibits, costing from ten thousand to one million dollars to mount, are mainly privately funded. Generous endowments from benefactor Gertrude Clarke Whittall in the 1930s continue to support two performance series at the Library: concerts featuring Mrs. Whittall's donated Stradivari instruments by the resident Juilliard String Quartet, and poetry and literature readings. The latter season opens and closes with readings by the nation's poet laureate, who is resident at the Library of Congress and spends part of each week from October through May at its Poetry and Literature Center. Poets in residence at the Library (called "consultants in poetry" until Robert Penn Warren was designated the first poet laureate in 1986) have included Robert Frost, Conrad Aiken and Rita Dove.

Library sales shops earn revenue from specialized books on the collections, knick-knacks, Washington memorabilia and more than a dozen different Library of Congress calendars.

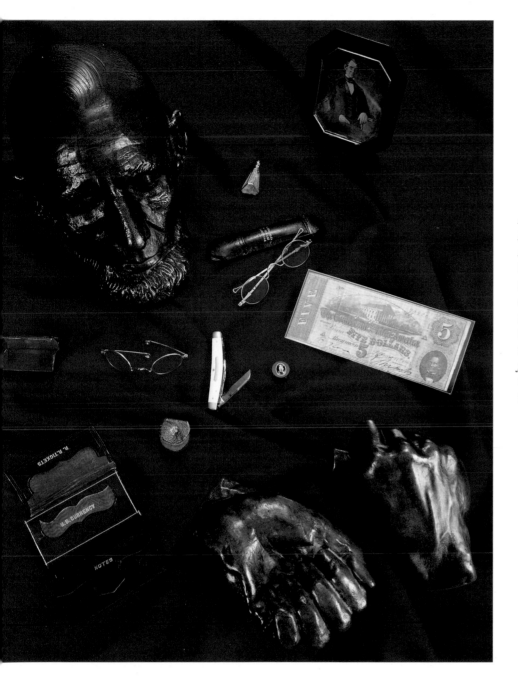

Left: Among the unusual artifacts in the Rare Book Division are Abraham Lincoln's life and hand masks, pictured here with the contents of his pockets on the night he was assassinated. The contents include two sets of eyeglasses (one repaired with a bit of twine), his wallet, a pocketknife, a button with a monogrammed "A" and a Confederate five-dollar note. (Lincoln had just returned from Richmond, Virginia.) (Photograph Carol M. Highsmith)

more than two million papers of twenty-three presidents through Calvin Coolidge. Other early presidential collections, such as James Buchanan's at the Historical Society of Pennsylvania, were kept at the state level. Once presidents (beginning with Franklin Roosevelt, followed by Herbert Hoover) began to establish presidential libraries, those libraries—under the aegis of the Archivist of the United

States—got the *personal* papers of those administrations, including those of Cabinet officers who served just those presidents. Personal papers of Cabinet officials like Henry Kissinger and Caspar Weinberger, whose public service spanned several administrations, are held at the Library of Congress. *Official* presidential records and correspondence are maintained at the National Archives.

The Library maintains six overseas offices in parts of the world that have only a limited publishing trade. These field offices in Jakarta, New Delhi, Karachi, Cairo, Nairobi and Rio de Janeiro are purchasing agents for both the Library of Congress and other great world libraries as far away as Australia. They are able to collect ephemeral material, such as pamphlets and fliers from different factions in an election. To bypass undependable international mail, the overseas offices ship via U.S. Army post offices or diplomatic pouch—paying a fee to the U.S. State Department.

The Library of Congress serves other American libraries, small and large, through its immense cataloging services. This took some doing at first, as the Library had only eight staffers—and others assigned to cataloging new copyright deposits—to tackle its nine hundred thousand items when it moved into its own building in 1897. Books were informally cataloged *by size*—a system still in use in many nations—then according to a complex scheme adapted by Thomas Jefferson from English philosopher Francis Bacon's "three faculties of science" (memory, reason, imagination) system. At the turn of the century, Librarian of Congress Herbert Putnam instituted a detailed Library of Congress alphanumeric system using subcategories of twenty "classes of knowledge" and began selling catalog

CENTERS FOR EXCELLENCE

Soon after he took office in 1975, Librarian Daniel Boorstin, a long-standing advocate of the book and of reading, took special delight in adding to what was already the world's greatest center for the book a separate, privately funded partnership *called* the Center for the Book. It connects the Library of Congress with the broader reading culture and uses the Library's name and prestige to promote the role of the book, print culture and reading in American society. With start-up funds from publishers McGraw-Hill and Time-Life Books and support from more than 130 corporations and individuals, the Center has arranged lectures, traveling exhibits, a "read more about it" public-service campaign on CBS Television and, by 1994, partnerships with more than thirty state centers for the book. "Books change lives" became its theme on posters and reading promotions in schools throughout the nation. The center also published more than fifty books, including *The Community of the Book*, a directory of reading and literacy programs like KIDSNET and the Barbara Bush Foundation for Family Literacy.

In the mid-1990s, the Library of Congress began to plan for other Centers of Excellence on such topics as Islamic studies, supported by the special collections.

Henry Oliver Walker's lunette on the east wall of the South Corridor in the Great Hall depicts Lyric Poetry, holding a lyre, surrounded (from left to right) by Mirth, Beauty, Passion, Pathos, Truth and Devotion. (Photograph by Carol M. Highsmith)

cards to other libraries. As it acquires books, periodicals and other materials, the Library catalogs them on microfiche, magnetic tape and CD-ROM.

The Library itself went "all electronic" and ceased using catalog cards in 1981. As thousands of local and university libraries also automate, they purchase the Library of Congress database on magnetic tape, saving an aggregate $350 million in the process. Thus the Library saves other institutions more money than it receives from Congress for its own operations.

In September 1989, the Library of Congress went online with twelve university and two federal libraries, giving their patrons dial-up access to the Library's electronic catalog, copyright database, congressional bill status service and referral information. Soon afterward, the Library's bibliography was opened to users worldwide via the Internet computer network. And for library patrons across America who have scoured local and state libraries and still not found a particular book, the Library of Congress sends out more than thirty-six thousand volumes a year via interlibrary loan.

The Library's appropriations do not pay for most exhibits, scholarly conferences, recordings, concerts, performances, staff travel or the thousands of Library of Congress publications—from an AIDS bibliography to a guide to Islam in sub-Saharan Africa. So its Development Office has intensified efforts to seek endowments and outside grants to support outreach activities.

They culminated in 1990 with the establishment of the Madison Council, the first-ever private-sector advisory board. Founders of the council, which would grow to

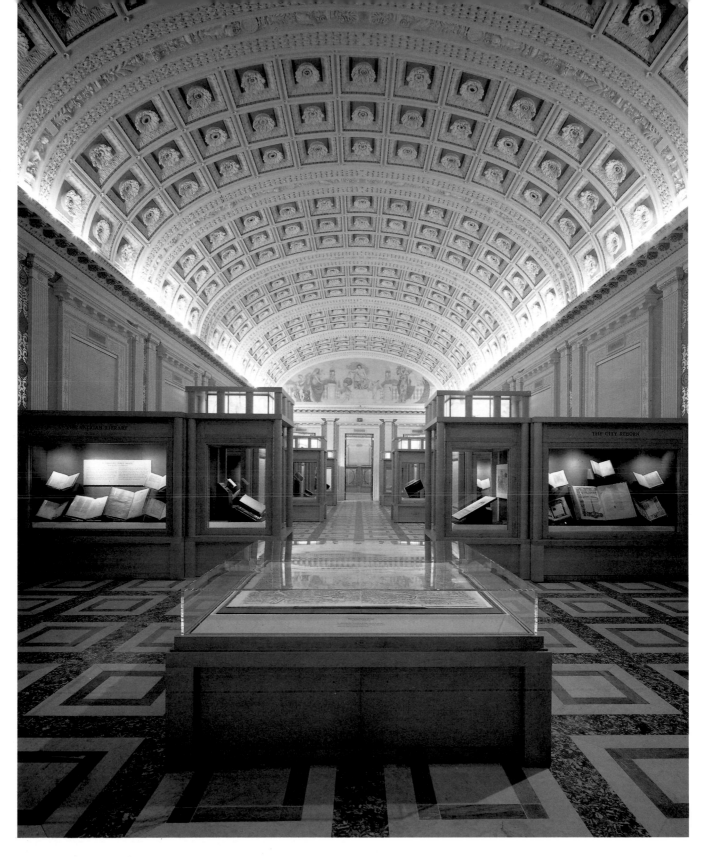

Above: The Vatican Library exhibit filled the South-west Gallery of the Jefferson Building. In Science*, Kenyon Cox's painting on the far wall, Astronomy is depicted as the central science, flanked by figures representing Physics, Mathematics, Botany and Zoology. (Photograph by Carol M. Highsmith)*

ninety members by 1994, included Chairman John W. Kluge, president of the Metromedia Company in New York. Each member agrees to contribute at least ten thousand dollars a year to a Madison Council Fund, which pays for projects such as paid fellowships for college students, public events during the "Jefferson Decade"—centering on the Jefferson Building reopening in 1997 and the Library's bicentennial in 2000—and a series of glossy color guides to its special collections.

Madison Council members who contribute one million dollars or more in a lump sum or over a period of years are inducted into the Jefferson Society, allowing them to select specific beneficiaries for their gifts. Conservationist Laurance S. Rockefeller's gift, for instance, supported the mounting of exhibits on President Calvin Coolidge and his era, and on the history of the American conservation movement, into the digitized collection.

Established, too, was the Millennium Foundation, a nonprofit corporation that allows the Library of Congress to enter into marketing ventures that generate income to build the core collections. One example: An outside vendor, signing over a percentage of profits, produced a line of Federal Period wall coverings and borders based on a rare group of American wallpapers in the Library's collection. In 1994, the Library of Congress also inaugurated a worldwide membership program. In addition to discounts on its books and artifacts, eligibility for behind-the-scenes tours and access to two rooftop restaurants, "national members" receive *Civilization*, a magazine that explores the Library's amazing and eclectic holdings.

A Special Service

The second-largest specialized division of the Library of Congress—next to the Congressional Research Service—is the National Library Service for the Blind and Physically Handicapped. With an annual budget exceeding $40 million, it serves three-quarters of a million Americans who cannot see or hold a book. Operating through libraries in every state but Wyoming and North Dakota, this service originated in 1931 to provide "embossed books" for the blind. Each year more than 21 million braille books and recorded books and magazines, including materials designed especially for children and seniors, are circulated free of charge. Among them are guides to activities like skiing and birding for blind and physically impaired individuals.

The National Library Service loans users disc or cassette machines and annually publishes more than two thousand books in braille or audio format, music scores and instruction in a variety of musical instruments, as well as reviews of talking books and books in braille. Looking ahead to the twenty-first century, the service anticipates an exponential growth in computer-digitized and synthesized-speech materials for visually impaired Americans. Gradually, it projects, these formats will eliminate the need for a National Library Service for the Blind and Physically Handicapped.

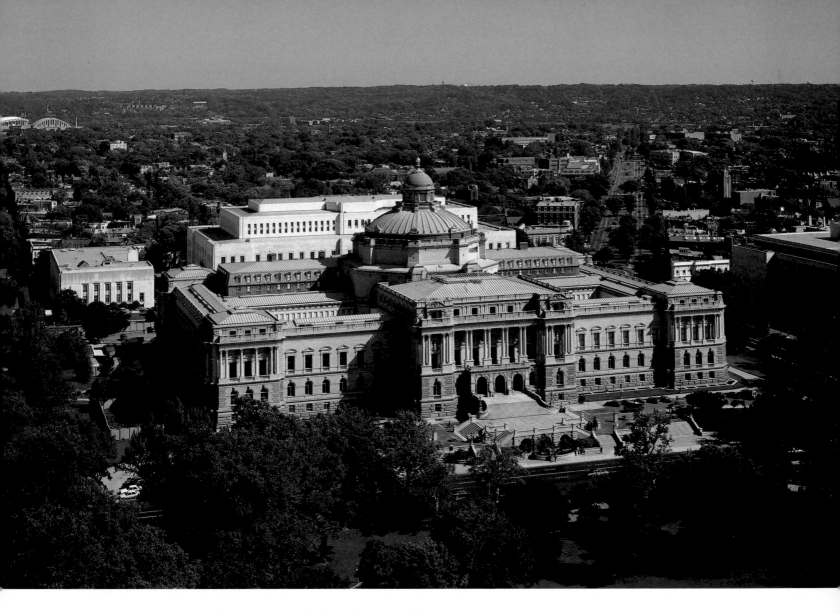

Above: Looking down from the Capitol, the Jefferson Building appears as a jewel in southeast Washington, D.C. The building's architectural and construction team, Bernard R. Green, Thomas L. Casey and his son, Edward P. Casey, was also responsible for the Old Executive Office Building near the White House. (Photograph by Carol M. Highsmith)

CHAPTER 10

Zeroes and Ones

All the world is not a stage. It's a series of ones and zeroes—the international digital language. Or so it seems, as the product of more and more human achievement becomes computer-readable. Astonishing breakthroughs like "virtual reality" and "artificial intelligence" portend greater changes in the next century than have transpired in a millennium. How is a knowledge-based institution like the Library of Congress going to be transformed in the Information Age? Dare it go about its business, whistling past the graveyard of outmoded technology and conventional thinking? Can the world's leading library rest on its dusty laurels while newspapers go online, digital "books" are published, photography and movies go digital and "new media" like computer networks and direct satellite broadcast to people in their homes and huts and cars bring "infotainment" to people everywhere on earth?

With Congress's support, Librarian James H. Billington determined that such a library cannot putter along a familiar road, cannot become "a mausoleum of culture rather than a catalyst for civilization," while the country's dynamic democracy accelerates onto the information superhighway.

Somehow, in times of flat or reduced government appropriations, it must find a way to preserve and sustain a universal collection and the "book culture," while pushing ahead with efforts to, as the title of a Library of Congress conference chaired by Vice President Al Gore worded it, "deliver electronic information in a knowledge-based democracy."

In his inaugural remarks in 1987, Billington talked about the responsibility of the "library without walls" to distribute not just cataloging information, but also the substantive *content* of the collection. "The Library must continue to move forward in establishing digital access to its collections," Billington told the House Appropriations Subcommittee in early 1994, "or risk becoming irrelevant to the knowledge navigators—librarians and educators across America—of the information superhighway of tomorrow." Electronic cataloging and the digitization of the collection are not "add-ons," he said. They're part of the core mission.

Even before he took office, many of the Library's functions had become "machine-readable," and Billington cracked the "multimedia" door still wider. Beginning in 1991, a new "American Memory" demonstration project cooked some of the most unusual of the Library's vast holdings—Revolution-era documents, Civil War photographs, the earliest motion pictures, more than twenty-five thousand old postcard views of the eastern United States, rare pamphlets and political cartoons—in electronic form, complete with their own catalog, and shared them with forty-four public and school libraries across America.

At about the same time the Librarian—a Russian scholar—was talking with Russia's new leaders about

bringing the old Soviet archives to light. Soon an exhibit of artifacts from those archives was mounted at the Library of Congress. It became the first of a series—the 1492 Columbus Quincentenary, Dead Sea Scrolls and Vatican Library Treasures exhibitions were others—to be put in electronic form and offered on Internet and the commercial America Online service to anyone who wished to punch them up. In 1993, the Library's LOCIS system—26 million catalog and research-guide records, including summaries of congressional bills dating to the 1970s—hopped aboard the Internet. And LC MARVEL—the Library's software that guides users through a maze of Library of Congress resources and plugs them into other great libraries' databases—went online the same year.

All the while, whether it was Prints and Photographs busily digitizing arrays of photographs, or Geography and Maps grappling with electronic files of cartographic information, or the Copyright Office paving the way for accepting machine-readable copyright registrations inside the Library of Congress, divisions were catching computer fever. Given the Library's chronic space problems, it helped that someone pointed out that a twelve-inch stack of optical discs can store the equivalent of one thousand feet of bookshelves.

Above: The Library typed its last catalog card in 1981 when it began to record all of its holdings on computer. Digital technology saves shelf space and provides easy access to information contained in books which, because of their fragility, may not be handled by the public. (Photograph by Carol M. Highsmith)

Of course digitized records will present their own preservation problems. Even if the raging debates over technology—the computer version of the old Beta versus VHS videotape debate—are settled and a stable presentation medium is agreed upon, will they hold up, the way a vellum Gutenberg Bible is so magnificently readable today?

In a casual conversation early in the 1990s, an official of the Massachusetts Institute of Technology media lab was explaining the latest electronic scanning equipment to a manager active in Library of Congress computerization. Right now, explained the man from MIT, specially designed x-ray machines can analyze a Renoir masterpiece by stroking through its layers and displaying them. What if, the two experts got to thinking, a machine could be developed that could scan a *closed* book and somehow copy each page inside into machine-readable form? If, in thirty seconds, the Library of Congress could inexpensively produce such a digitized copy, it is no longer far-fetched to imagine the day when most of the wonders assembled under the Library of Congress roofs might be made available to anyone, anywhere, who hits the right keystrokes.

Digital scanning is expensive. If it costs five dollars a page to scan, that's fifteen hundred dollars for one three-hundred-page book—$1.5 million for a thousand of them. Where would $1.5 *billion* be found to digitize a million books?

For sure the day is not far off when those who use "windows" on their home computers will be able to "run" an old movie from the Library of Congress collection, using remote-control buttons on the screen, while at the same time scanning cataloging information about the film or

related subjects, and also perhaps reading text from a newspaper of the times. By 2010, most of the Library's newspapers and periodicals may be stored electronically, and its staff will likely retrieve "current issues" not from a wooden stand in the reading room, but electronically from publications' own computer files. Scanning technology will have reached the point that not just books in English, but also works in other alphabets—and even handwritten manuscripts and margin notations—will be captured by computer and made available to classrooms and homes.

Soon more people will "visit" the Library of Congress each year via computer than will walk into the Jefferson, Adams and Madison buildings in Washington; more than one hundred thousand people alone tapped into the Russian archives exhibit in the first year it was offered on computer networks. As electronic "books," manuscripts and digital journals begin to zip into the Library of Congress, the whole copyright registration and licensing process will have to be rethought.

Suddenly the Library of Congress exists not just in Washington, but everywhere on earth that a computer can be plugged in. It's not just Congress's—or even the nation's—library anymore, but an information cornucopia that can spill into the humblest electronically equipped homestead in New Braunfels or Newcastle or Nuku'alofa.

If it moves *too* fast, a 1994 *Washington Post* editorial pointed out, the Library runs the risk of offering better access to those who are "wired" than to "the non-hooked up [who] can come in and actually hold a book in their hands."

Never fear, assured Billington. Libraries will continue to offer information access to the poor. Just as they have

opened the world of books, libraries will offer computer terminals that unveil the world of electronic information to any and all. Library officials will hie to a twentieth-century lesson—that new technology usually does not displace, but rather enhances, old ones. Radio did not kill newspapers, nor did television cause the demise of radio, and every day brings an announcement of a new use for the telephone. So, properly directed, seductive computer technology could prove to be the book's salvation.

Like Christopher Columbus more than five centuries ago, Librarian Billington launched the good ships *Jefferson, Adams* and *Madison* onto uncharted and occasionally treacherous seas, where calls for his head sometimes sounded. There are no Medicis, no patron queens funding the journey. The "downsizing" demanded, first by the Gramm-Rudman spending caps of the 1980s, then by the "reinventing government" mandate of the early 1990s, constricted funds, staff and resources. Witness the closing, in the early 1990s, of the Library's reading rooms on Sundays and some evenings, the cancellation of foreign interlibrary loans, the loss of the budgetary equivalent of 573 employees in the first four years of the 1990s—while the collections were increasing by 20 percent—and the pitiful funding available for staff travel. So this explorer reached out for help to benefactors, other institutions and even businesses in what Billington called the "productive private sector." This raised some hackles but, according to *Library Journal,* also helped soften the Library's perceived "holier-than-thou" image.

Endemic space problems will force the move of millions of items to new storage facilities on one hundred

acres of land obtained in 1994 at Fort Meade, Maryland. The Library's 1993–2000 strategic plan called for "the establishment of a remote research campus to which a significant, coherent body of the collections and operations can be relocated."

"I cannot stress too emphatically how unique and important it is to have a universal collection," Billington told the authors of this book. "If we hadn't kept a lot of old books from the last century, one of the major breakthroughs in cancer research wouldn't have occurred. People at Sloan-Kettering tell me there was a book published in German in the 1840s that wasn't available in Germany that gave them a major clue on leukemia research. American officers in Operation Desert Storm (during the Persian Gulf War of 1990–1991) wouldn't have known that the sands of Iraq could carry heavy tanks and land carriers if they hadn't read obscure travel books and archaeological books of which we had the only copies. So there are all kinds of dramatic uses, and there are all kinds of creative uses that come from the great variety of collections here. Getting this better known in the land is simply a way of informing the American people about the returns on their investment in us."

Index